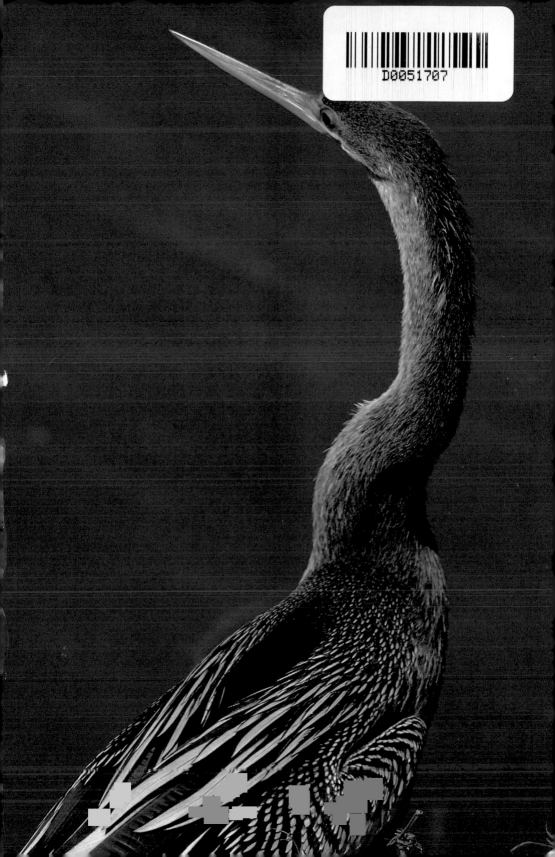

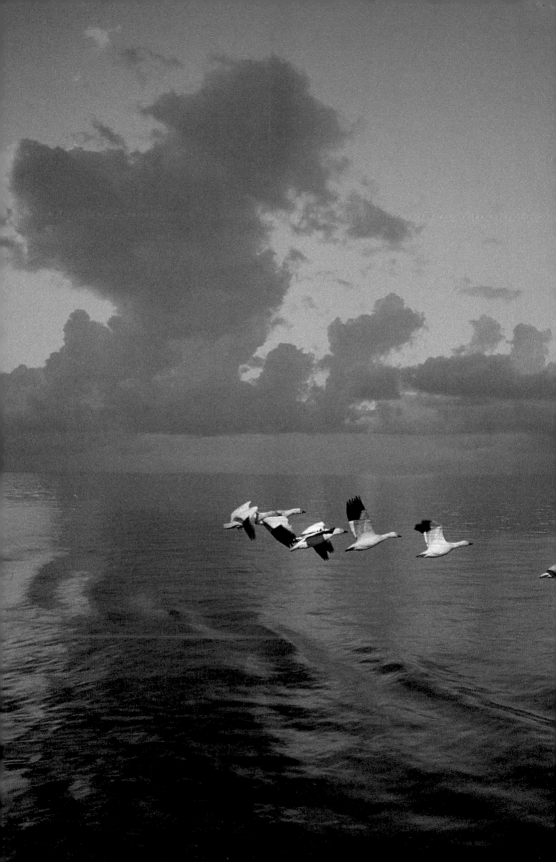

THE FIELD GUIDE TO PHOTOGRAPHING

BIRDS

CENTER FOR NATURE
PHOTOGRAPHY SERIES

ALLEN ROKACH
AND
ANNE MILLMAN

AMPHOTO BOOKS
AN IMPRINT OF WATSON-GUPTILL
PUBLICATIONS/NEW YORK

To Steve and Rube Jacobson,

for opening our eyes to the wonder of birds

PICTURE INFORMATION
Page 1: Anhinga. The Everglades, Florida.
Pages 2-3: Snow geese. New Jersey.
Page 5: Mergansers. Acadia National Park, Maine.
Page 6: Dove. Sonoran Desert, Arizona.

Senior Editor: Robin Simmen
Editor: Liz Harvey
Designer: Bob Fillie, Graphiti Graphics
Graphic-production Manager: Hector Campbell

Text by Allen Rokach and Anne Millman
Photographs by Allen Rokach

Copyright © 1995 by Allen Rokach and Anne Millman
First published 1995 in New York by Amphoto Books,
an imprint of Watson-Guptill Publications,
a division of BPI Communications,
1515 Broadway, New York, NY 10036

Library of Congress Cataloging in Publication Data
Rokach, Allen.
 The field guide to photographing birds/by Allen Rokach
and Anne Millman.
 p. cm. — (Center for Nature Photography series)
 Includes index.
 ISBN 0-8174-3873-4
 1. Photography of birds. I. Millman, Anne. II. Title.
III. Series: Rokach, Allen. Center for Nature Photography series.
TR729.B5R65 1995 95-23116
779.9'32—dc20 CIP

Manufactured in Singapore

1 2 3 4 5 6 7 8 9/03 02 01 00 99 98 97 96 95

ACKNOWLEDGMENTS:
Many people helped bring this book into
being, directly and indirectly.

Mary Suffudy encouraged us to pursue
this book series when she was the publish-
er at Watson-Guptill. Without her faith
and invaluable guidance, this project
would never have begun. We also want to
thank Liz Harvey, our editor at Amphoto
Books, for keeping our noses to the grind-
stone and gently (and perhaps not so gen-
tly) making sure that we finished on time.
We appreciate Liz's determination to cre-
ate a series of high-quality books that are
well designed and produced.

We also haven't forgotten colleagues
whose early support meant so much dur-
ing the long, laborious process of shoot-
ing bird images. In particular, we want to
acknowledge Ann Guilfoyle, former pic-
ture editor at *Audubon* magazine, and Tom
Page, designer at *Natural History* magazine,
for boosting Allen's early endeavors in
bird photography. And we remain grateful
for the ongoing support and encourage-
ment we've gotten over the years from
Herbert Keppler and Jason Schneider of
Popular Photography magazine.

Special thanks to those who spon-
sored our various travels, which were
invaluable to our efforts to gather images.
We are especially grateful to our friends at
Olympus America, including John Lynch,
Dave Willard, and Marlene Hess, as well
as former Olympus staff members Bill
Schoonmaker and Pasquale Ferazzoli. We
also thank Odette Fodor, KLM director of
public relations; Kathy Barbour, of Thai
Airways International; Nat Boonthanakit
and Suraphon Svetasveni of the Tourism
Authority of Thailand; Barbara Veldkamp
of the Netherlands Board of Tourism;
Barbara Cox of Royal Cruise Line; and
Priscilla Hoye of Cunard.

A few words of appreciation to Ed
Carlson, manager of the Corkscrew
Swamp Sanctuary, for his help and coop-
eration; and to Kay Wheeler and Sidney
Stern, whose tireless help in the office and
studio has moved many projects to com-
pletion.

Finally, to our friends Frank Kecko
and David Ferguson. They've been helpful
companions on our many picture-taking
trips together, and they really made these
excursions fun.

Contents

Introduction

Birds have a special place in our hearts. It isn't just that Allen and I think that birds are wonderful, beautiful, and fascinating, though all that is true. And it isn't just that watching them has given us great joy. Birds mean a great deal to us because they are what first brought us together.

Allen and I met in a birdwatching class that The New York Botanical Garden offered back in 1975. He was the instructor, and I was a student, taking the course as a perk for my volunteer work at the Garden. I'd always wanted to be more knowledgeable about birds and learn how to observe them, so I jumped at the chance to do just that right near home. It wasn't until the end of the course that I discovered that Allen was a photographer and he discovered that I was an aspiring writer. Shortly thereafter, we were trying to peddle a jointly conceived article on—what else?—photographing birds. *The New York Times* picked up this initial effort, which led to other joint projects for that newspaper's photography column.

In the meantime, Allen and I sent the bird-photography article to other publications, hoping to gain entry into the magazine market. Once again, birds opened doors for us: we did variations on our original piece in several travel-related periodicals. Allen then received requests to photograph birds to illustrate various articles in nature oriented books and magazines.

When I wasn't Allen's co-author, I was often assisting in other ways. I'll never forget the time he had an assignment for *Natural History* magazine to photograph terns for an article called "Terns in Traffic." Allen and I arrived at New York's Jones Beach, literally hugging the lanes of the highway. The birds were oblivious to the cars carrying throngs of beachgoers and sun-and-surf worshipers, and vice versa. A scientist had studied how surprisingly well the terns fared despite the noise and fumes, and Allen's job was to illustrate this thesis.

To get the shots, Allen and I came armed with hardhats because we knew that these birds behaved like dive-bombers. And if they weren't attacking using both their sharp beaks and high-pitched squawks, they were shelling us with their unique form of ammunition. It took us awhile to figure out what to do, but we finally learned how to keep the birds at bay until Allen was ready for another series of takes. That is when I had to make my move, stirring up the colony and exposing myself to repeated assaults. This experience certainly gave me an appreciation of what it takes to capture marvelous bird images.

So this book seems like a fitting culmination to those years of being with birds all around the world. Although our work has taken us in many different directions over the years, we truly still love watching birds, even when no work is involved. Just this year, for example, Allen and I spent time in Florida at Ding Darling and other bird sanctuaries. Allen didn't bring a camera along; we simply enjoyed watching magnificent creatures charging the breaking waves, swooping into their rookeries at the end of the day, and trying hard to hide.

Seeing the birds gave us much pleasure. I am, however, also glad when Allen goes beyond birdwatching to bird photography. Otherwise, I wouldn't have a stunning shot of two skimmers in flight on my office wall. And no one would have the images in this book to contemplate. Thank goodness some people still care enough to record the wonders of nature.

ANNE MILLMAN

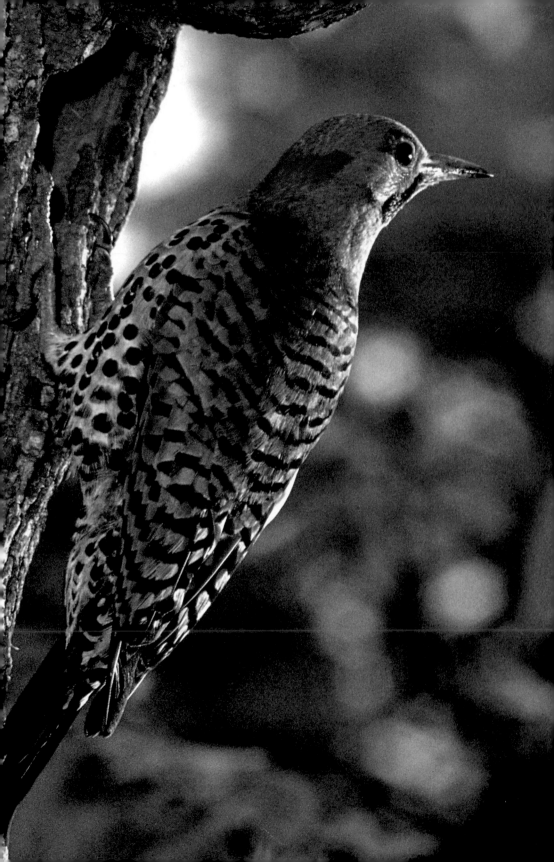

Portraying Birds Creatively

I was working in New York City's Central Park on a spring outing when I saw this flicker on a tree. Suspecting that the bird had a nest nearby, I watched as it continually returned to its favorite perch. To set up for my shot, I focused on its resting spot. One time when the flicker came back, I was able to get several shots, including this one showing its watchful, jittery movement. With my Nikon F2 and Nikkor 300mm telephoto lens, I exposed at f/4 for 1/250 sec. on Kodachrome 64.

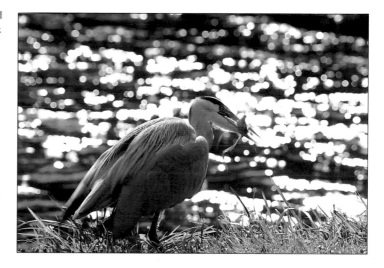

In bird photography, creativity and preparation go hand in hand. When I noticed this great blue heron fishing in the canals of Holland, I knew that in minutes I would have a good chance of showing this magnificent bird engaged in a typical activity. By anticipating the movement; determining my purpose; and setting up in advance with a long lens, wide-open aperture, and fast shutter speed, I was all ready when the heron came back with its lunch. Here, I used my Olympus OM-4T and Zuiko 300mm telephoto lens. The exposure was f/2.8 for 1/500 sec. on Fujichrome 100 RD film.

O f all the creatures in the natural world, the most accessible are birds. You may have to travel long distances to glimpse other wildlife, but you can find birds right in your own backyard. They certainly make the effort worthwhile, so it is no wonder that bird-watching is one of the fastest growing and most popular pastimes, nationally and worldwide. If you enjoy looking at birds, chances are that you've thought about photographing them. But even if you are new to the world of birds, your interest in nature photography is likely to bring you in contact with birds on a regular basis.

A downward perspective from the edge of a pond was required to show the shape, colors, and textures of this redhead duck. The bird was fairly close—just about 5 feet away—but it continually moved along the edge of the pond. As such, keeping it separate and distinct from the other ducks and the floating debris on the lake was a challenge. I preset my Zuiko 35mm wide-angle lens to include some of the surrounding water for color contrast and to set the bird in context. When the right moment arrived, I made this shot even before I saw it through the viewfinder of my Olympus OM-4T. The exposure on Koda-chrome 64 was f/5.6 for 1/125 sec.

Whichever path brought you to this juncture, you may need to do some adjusting before you move forward with your photographic venture. As an avid birder, you'll need to master aspects of photography. And as an avid nature photographer, you'll have to develop new skills to stalk your photographic prey.

Either way, these photographic pursuits are sure to be rewarding. Seeing birds in the wild is thrilling in its own right. But nothing compares to the exhilaration of successfully creating still images that capture the evanescence of birds.

Of course, this undertaking has a technical dimension. But before you get mired in the how-to details—the rest of this book will give you plenty of that—you should take a look at what the visual possibilities are. This may require you to rethink your approach to birds: to study them not only as living creatures, but also as visual subjects. Making this mental transition is the first step toward learning how to portray birds creatively. As you read this chapter, start imagining the many different ways you can photograph birds.

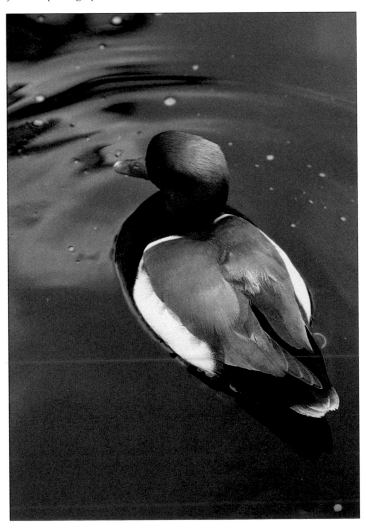

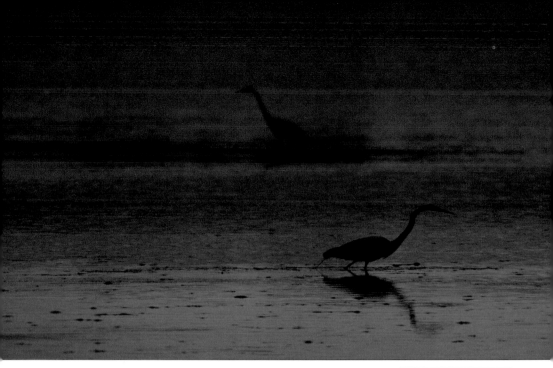

THINK VISUALLY

Still photography has the great advantage of giving you the time to look, consider, and enjoy a subject for as long and as often as you like. This is why photographers work so hard to frame an image that will be worthy of—and can withstand—prolonged scrutiny. The more you learn to think visually, the more you'll look at every occasion as a chance to make an effective photograph. Even if the impetus for a shot is scientific and your primary interest is to convey useful information, you'll determine the value of your image in purely visual terms.

Thinking visually means looking beyond the raw material that you see with your eyes. You need to understand how photographic equipment can transform or enhance this material in order to create a distinctive image. As you begin your efforts, pause to consider the following questions:

■ **Did I fill the frame?** Photographers are frequently disappointed with their bird pictures because their subjects are barely visible. The bird is lost in the frame, and, even more important, what is left in the frame is of little visual interest. Birds are often small, far away, and on the move. Your task as a photographer is to come up with an effective image despite the obstacles you face. Whether this means using specialized equipment or finding imaginative ways to compose bird pictures, you must fill the frame in a way that will make the entire shot meaningful.

■ **Did I organize the visual elements?** Look at birds and their surroundings as discrete features that you, as a photographer, can arrange into a balanced whole. Build your composition around such elements as color, texture, line, shape, and repetition. Check to see if a vertical or horizontal format works best to encompass them. And be sure to move around and change your perspective until the composition works for you. Even though you may have to work quickly, don't let the need for speed undermine the clarity and coherence of your composition.

The magnificent sunset illumination at Florida's Ding Darling Wildlife Refuge became the visual focus of this shot of two egrets feeding in the water, some 250 feet away. While the silhouetted birds are relatively small in the image, the picture's impact is based on the effect of light on the surroundings. The scene was quite dark when I was working, so I overexposed it by 1 1/2 stops to brighten the color. Shooting with my Olympus OM-4T and my Zuiko 350mm telephoto lens, I exposed at f/2.8 for 1/8 sec. on Ektachrome 64 Professional EPX film.

■ **Have I made the most of the natural light?** This type of illumination
can add immeasurable beauty to your final image if you know how to
make it work for you. Notice the qualities of light at various times of day,
through the seasons, and under different weather conditions. Birds are
most active and accessible early and late in the day when sunlight can be
warm and low-angled. Pay attention to how light plays up the colors and
textures of birds' feathers, as well as how it delineates the shapes of birds.
If the light on the surroundings is particularly dramatic, make that your
focal point, even if the bird becomes a silhouette. Whenever possible, let
the glow of light suffuse your bird image.

■ **How can I prepare for motion?** The continual movement of birds
makes them both fascinating and frustrating to find and photograph.
Fortunately, the motions of most birds are fairly predictable. Whether
birds are flying, feeding, or grooming, they tend to repeat their actions.
This gives photographers a chance to plan ahead for a particular motion
and decide in advance how to best render it. Your still camera gear gives
you a distinct advantage here. When you think visually, you can decide
how to record the movement; you can vary the shutter speed according
to whether you want to freeze the movement at a decisive moment or to
portray it with some blurring. As your ability to anticipate how birds
move develops, you'll have many opportunities to experiment with this
dimension.

KNOW YOUR PURPOSE

When you approach birds to photograph them, you shouldn't act like an
obsessive investigator searching for evidence. No matter how intensely
you go about the business of capturing birds on film, don't lose sight of
the pleasure that comes from observing these delightful wild creatures.
To prevent you from losing sight of your true purpose with each shot,
you should assume the attitude you would have if you were taking pic-

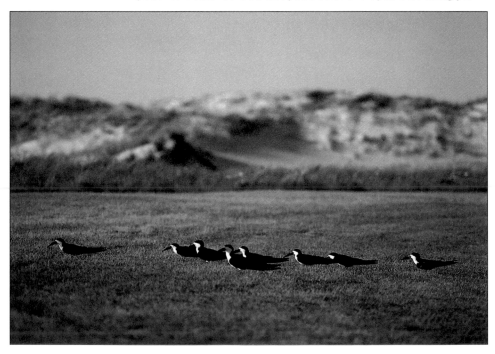

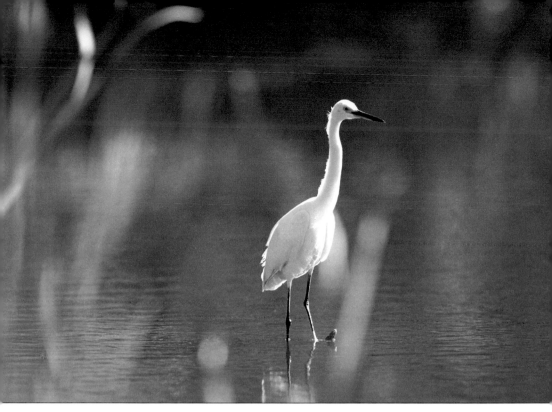

tures of young children. This mental shift should immediately suggest a variety of possible reasons for taking a picture, as well as alert you to the delight you feel as you move from simple documentation to more challenging shots.

Of course, the rewards with photographing birds, as with children, are enjoyed by both those who observe such subjects closely and patiently, and those who are ready when an opportune moment arrives. And don't be discouraged if you realize that a portrait is impossible. You can capture birds on film many excellent ways. Here are some to keep in mind.

Documentary Portraits. These are often the most demanding bird pictures to shoot, but they aren't always the most interesting to look at. Their chief value is showing exactly what a bird looks like, with as much detail as possible. Bird portraits are rarely effective unless they include the bird's eye, preferably with a glint of light hitting it, and, if possible, some of the bird's identifying field marks.

Photographers rarely take such portraits off the cuff. In fact, these shots require a great deal of planning and preparation. Photographers whose primary goal is to successfully shoot bird portraits have to find a nest or some other location where birds return reliably. The photographers may even set up blinds and electronic triggers for remote-controlled equipment. If you don't own this specialized gear, your best bet is to find a relatively open area with subjects that stay reasonably still. For example, try taking portraits of larger, less flighty birds, such as swans, ducks, or geese, in wetlands, ponds, parks, and nature centers.

Environmental Scenes. When you can't get close enough to shoot good bird portraits, you can work on depicting your subjects in the context of their natural habitat. You may decide to include more or less of the

One of the best ways to show birds that are too far away to fill the frame is to incorporate aspects of their surroundings. Keeping this approach in mind, I framed this egret with the grasses that are common in Florida's Everglades National Park. By moving close to the foreground vegetation while focusing on the bird, I was able to blur the grasses to create this evocative impression. With my Olympus OM-4T and Zuiko 350mm lens, I exposed for 1/500 sec. at f/5.6 on Fujichrome 100 RD film.

To create this image of a great blue heron in Florida, I had to weigh various technical options. I selected my Zuiko 350mm lens so that the bird would virtually fill the frame, even from a shooting distance of about 30 feet. Then I decided to base my exposure on a spot-meter reading of the bird, which was much brighter than the water behind it. I knew that this would help set off the heron by darkening the background and bringing out the bright highlights on its beak and feathers. With my Olympus OM-4T and Zuiko 350mm telephoto lens, I exposed at f/2.8 for 1/250 sec. on Fujichrome 100 RD film.

environment in the photographs. For example, you may photograph an egret standing among tall marsh grasses or a seagull flying against a city backdrop. Such images can be both informative and compelling.

If your purpose is to combine birds with their natural surroundings, you'll have to devote some effort to finding the best perspective and light for showing the environment. Next, you'll have to concentrate on making the natural setting a striking visual context for the birds.

Action Shots. Paradoxical though it may seem, capturing birds in motion is actually easiest when you don't move around quickly. Slowing down gives you the time you need to think about the kind of action you are likely to encounter and exactly how you want to represent it. You'll have to use different techniques to freeze the action, follow the action, or show the progress of the action (see page 50).

The more you know about bird behavior, the better you can anticipate what might happen. You'll be on the lookout and ready for the eventuality. And remember, if you see the movement of the bird through your viewfinder, you'll probably have missed your chance to record it on film. But because birds tend to repeat their motions, you'll probably still have several other opportunities to show the action.

Expressive Renditions. Just as pictures of children are most endearing when they show facial expressions, shots of birds are most evocative when they reveal a bird's distinctive nature. As you shoot, notice what is special about each type of bird, such as an anhinga's shape, a hawk's posture, or a tern's swooping movements. Whenever possible—and, admittedly, this can be a challenge—try to capture the characteristic quality or trait in your image. To make this task a bit less daunting, think about each bird's typical traits rather than those that are unusual or rare.

UNDERSTAND THE TECHNICAL OPTIONS

Thinking about how you want to portray birds is important because an image can only be as good as the photographer's intentions. Without a purpose and vision, each shot is simply a matter of luck. But with a purpose and vision, you have something to aim for: a picture in your mind's eye.

To achieve this goal, however, you also must understand how to control your photographic equipment, so that it produces the desired effect.

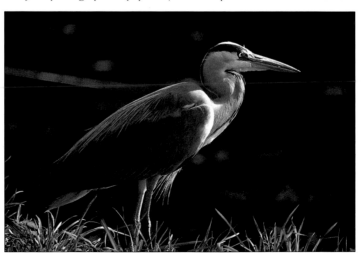

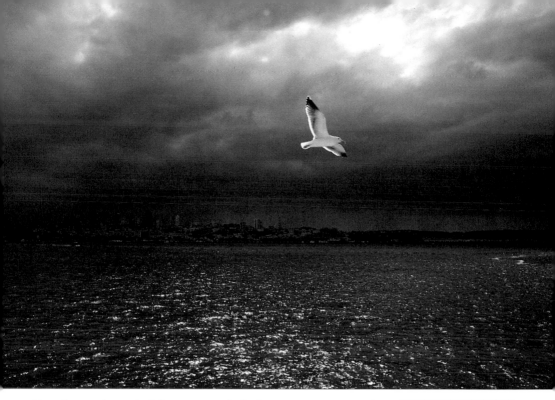

Your choices about which lens to use and which settings to use can make or break your bird photographs. With experience and practice, your technical decisions will become second nature. At first, however, don't be surprised if it takes you a bit of time to get a clear understanding of how each selection will affect your final image. Even seasoned bird photographers carefully consider each of the following options before they start to shoot.

Choice of Lenses. When bird photographers talk about lenses, the conversation usually runs from long, to longer, to longest. Although birds undoubtedly occupy telephoto-lens territory, from 200mm to 800mm, other lenses have a place in bird photography. The reason is simple: birds are relatively small, and they tend to keep their distance. Even in rare instances when you can get reasonably close, chances are you'll want to use a telephoto lens to magnify the bird. In addition, long lenses have a shallow depth of field, a feature that enables you to blur an unwanted backdrop (see below).

Exposure Options. Achieving proper exposure is one of the most complicated technical aspects of bird photography. First, you need to take an accurate spot-meter reading, which is no easy task when the bird is moving. Then, depending on the lighting conditions and the color of the bird, you may want to under- or overexpose in order to fine-tune the results. To complicate things further, you should keep in mind that exposure is the product of aperture and shutter speed, settings that also affect depth of field and subject motion, respectively.

If all of this tempts you to give up completely on making intelligent decisions about exposure, don't despair. Automatic-exposure camera features were invented for this very reason. These options are quite helpful, especially when a bird is moving around. Even if you opt for autoexpo-

While riding on a ferry from San Francisco to Sausalito, California, I noticed a solitary gull hovering above the boat. Against a cloud-filled sky and with the city as a backdrop, the bird stood out dramatically, especially when a ray of sunlight shone on its white feathers. But I wasn't prepared for bird photography; in fact, I had my Nikkor 21mm lens on my Nikon F2 because I planned to shoot wide-angle seascapes. Nevertheless, I was tempted to try for a shot that combined the bird and this magnificent setting. To freeze the movements of the bird and the boat, I used a very fast shutter speed, 1/250 sec. I exposed at f/5.6 on Kodachrome 64.

Opportunities for unusual bird photographs arise all the time if you are alert to them and have the right gear. I was going back to my car in Florida's Ding Darling Wildlife Refuge when I noticed a bird fluttering around another car. At first, I thought that it was an ordinary house sparrow admiring itself in the car's mirror. But when I looked at my subject through my Zuiko 350mm telephoto lens, I discovered that it was a rare prairie warbler. I had to use a 25mm extension tube to focus from such a short distance. Luckily, the bird was still looking in the mirror when I was ready to shoot. With my Olympus OM-4T, I exposed for 1/500 sec. at f/2.8 on Ektachrome 64 Professional EPX film.

When I know I'll be photographing birds, I scout locations in the middle of the day, talking to naturalists and birders I meet along the way. Then I return to those spots late in the day or early in the morning when the illumination is usually better and more birds are around. At Florida's Ding Darling Wildlife Refuge, I saw this egret moving slowly out into the open and then behind the mangrove trees. I kept following the bird, shooting in the hopes of getting a good picture. After 20 minutes, the egret made its way toward me into an open area 150 feet away, where I was able to shoot many images of its feeding behavior in the warm light of sunset. Working with my Olympus OM-4T and my Zuiko 350mm telephoto lens fitted with a 1.4X tele-extender, I exposed at f/2.8 for 1/250 sec. on Fujichrome 100.

sure, however, you should take control of the final outcome by identifying your priorities. Think about what is more important to your image: how you want to render the background, which calls for the aperture-priority mode, or how you want to depict motion, which calls for the shutter-priority mode.

Rendering the Background. A key aesthetic decision in bird photography is whether the background behind your bird subjects should be sharp or out of focus. You may prefer to blur a distracting backdrop or jumbled surroundings. A camera's ability to throw the background out of focus increases when you move closer to your subject, use a longer lens, or select a shallower depth of field by using a wider aperture setting. (The reverse applies for recording sharp backdrops.) Choose a lens and aperture setting that will create the effect you want, keeping in mind how close you can get to your subject and how much magnification you'll need. Use your camera's depth-of-field preview button to check the results before you shoot. If you're depending your camera's autoexposure capabilities, select the aperture-priority mode to maintain depth-of-field control, and then let the camera choose the corresponding shutter speed.

Depicting Motion. When your subject is moving, you can either stop or record the bird's motion. If you are within 15 feet of your subject, you can use a fast shutter speed, augmented by a fast film and an electronic flash unit, to freeze movement. Alternatively, you can either record the flow of the motion as a blur by using a slow shutter speed, or follow the motion by panning with your camera. In either case, if you use your camera's autoexposure mode, you'll need to set it on shutter-priority. Here, you select the best shutter speed for your purpose, and let the camera choose the appropriate aperture setting. But the most important factor for successfully capturing the movement of birds is anticipating exactly what they'll do.

ANTICIPATE AS YOU SHOOT

Your excursions into bird photography will be much more rewarding if you develop a keen awareness about the habits of birds. Start by learning their seasonal migratory patterns. These will tell you which birds are year-round residents and which ones pass through your immediate area certain months of the year.

Next, you should investigate the birds' feeding and breeding preferences. These will reveal the most fruitful locations for finding subjects. Many birds congregate along waterways because that is where food is plentiful. You are likely to find huge flocks of gulls, terns, and ducks along beaches and shorelines. You'll come across shy shorebirds, such as egrets, as they fish in shallow wetlands. Berry or seed eaters are easiest to spot during the winter, when they gravitate toward feeders or natural plantings of berries, seeds, or nuts. Look for birds with a taste for insects in bogs or near decaying trees and other vegetation.

Finally, observe the various behaviors that are typical of each species. Watch as the birds take off or land, stalk their prey, scramble along a road or sandy beach, groom themselves, or tend their nests. The more you look, the better you'll understand birds, and the greater your chances of capturing their most telling behaviors on film. Once you learn the basics of bird behavior, you should keep the following points in mind:

■ **Press the shutter-release button before the action occurs.** As you practice, always anticipate a bird's activity by depressing the shutter a

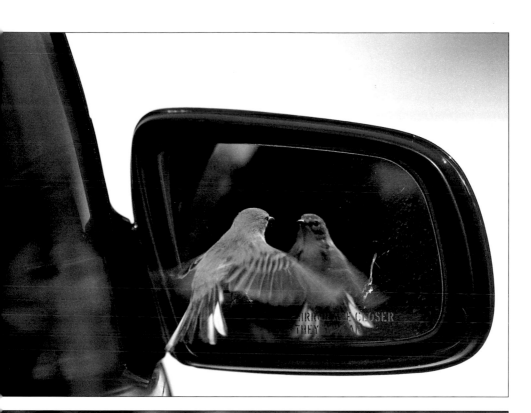

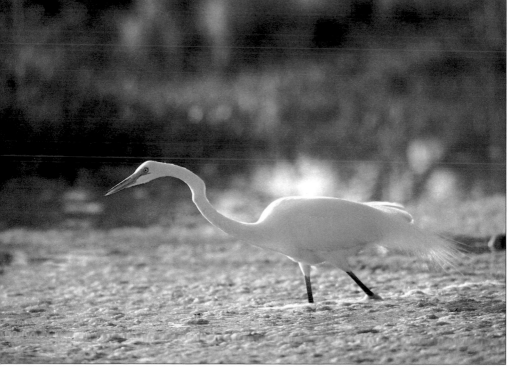

17

Terns are skittish creatures that don't appreciate unwanted visitors, especially when they're tending their young. To capture this tern landing at its nest at Jones Beach, New York, I kept a respectful distance of 15 feet and laid low to become part of the scenery. Once the birds grew accustomed to my presence, I was able to set up the shot and simply wait for the tern to make one of its frequent return landings to the nest. I used a shutter speed of 1/1000 sec. to freeze the moment when the bird's wings were fully extended. With my Nikon F2 with a motor-drive and my Nikkor 300mm telephoto lens mounted on a tripod, I watched the bird carefully, but not through the viewfinder. Pressing the shutter-release button a split second before the bird landed, I exposed Kodachrome 64 at f/4.

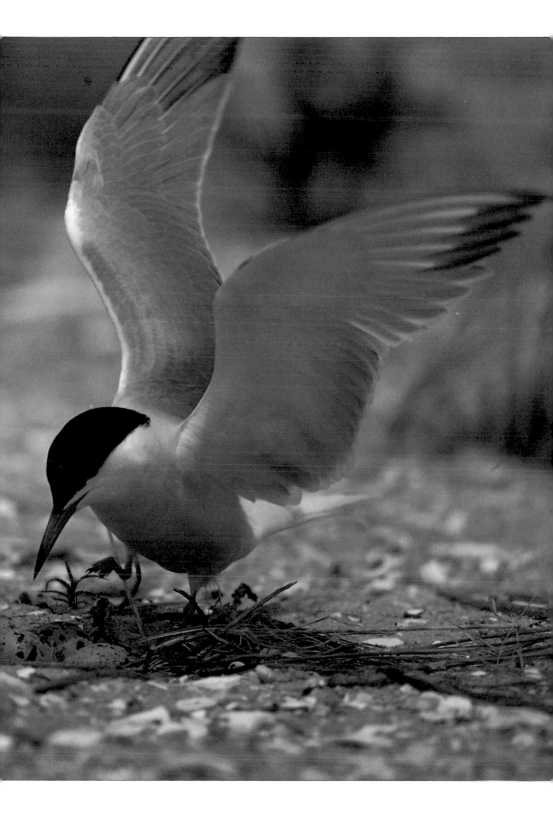

When I first noticed this great blue heron in San Francisco's Golden Gate Park, I thought that shooting through the mass of foreground grasses would be too difficult. But I decided to try this unusual perspective anyway. I moved until I found an area where the grasses were a bit thinner, and I composed the shot, lying on my belly, so the grasses framed the bird. Next, I selected a wide-open aperture and the equivalent of a 500mm telephoto lens to narrow the depth of field, thereby throwing the foreground vegetation out of focus. With my Olympus OM-4T and Zuiko 50-250mm zoom lens set at 250mm and fitted with a 2X tele-extender, I exposed Kodachrome 64 for 1/60 sec. at f/5.6.

When photographing this egret in Florida, I was able to enhance the mood by imaginatively silhouetting the bird against a sunset sky and surrounding it with reflections of clouds in the water. Slight underexposure and the use of a warming filter added to the intriguing atmosphere and the sense of mystery. Shooting with my Olympus OM-4T and my Zuiko 350mm telephoto lens, I exposed at f/2.8 for 1/30 sec. on Fujichrome 100.

split second before the decisive action occurs. As mentioned earlier, once you've seen the action, it is too late to record it on film. For example, if you see a bird resting on a perch, its posture may provide a clue about when it is going to take off. To capture the instant of uplift, set up the shot as fully as possible—framing, exposure, aperture, shutter speed—and then snap the picture as soon as you notice the telling behavior that indicates that the bird is ready to make its move. Similarly, if you're watching a bird at its nest, set everything up, keep watching for any interesting behavior, and fire away as soon as you sense that something is about to happen.

■ **Be persistent.** The compensation for bird-watching and bird photography is a result of patience and persistence. If you wait long enough, you'll get what you were looking for. For true bird lovers, as with doting parents and grandparents, waiting and watching for the payoff is part of the pleasure. Following a bird's path, anticipating what the bird will do next, and waiting for the moment to happen require intensity and concentration. True devotees think nothing of coming back to the same spot, time and again, hoping for the right convergence of bird behavior and light to get exactly the shot they want.

■ **Practice often.** The skills required for bird photography take some getting used to. Keep them current and sharp by practicing often and close to home. You can attract birds to your backyard with feeders, water baths, and appropriate plantings. Another option is to visit a nearby park, zoo, or nature center, where you'll definitely find subjects to photograph. Then, when a special opportunity arises to visit a far-off bird sanctuary, your technique won't be rusty.

EXTEND YOUR IMAGINATION

As you develop a keen sense of the kind of images you want to produce and as you master the techniques you need to achieve them, try to become increasingly daring and imaginative in your photography. Keep reminding yourself that you can depict birds many ways, and that what counts is that you create a thing of beauty. Let your images take on a life of their own, and let them become reflections of your individual perception, as well as portrayals of the world of nature.

Most important, however, don't limit yourself to a narrow sense of what bird photographs should be. Move beyond portraiture to create a variety of visual representations with your camera, with birds as their focal point. Here are a few suggestions:

■ **Evoke a mood.** Birds have symbolized a wide range of feelings and longings throughout the ages. Birds can suggest everything from freedom and love to fear and loneliness. Try to establish a feeling via the way you portray birds in your images.

■ **Create an impression.** While most bird photographs strive for clarity and sharpness, you can use some fascinating approaches to realize more impressionistic images. Envelop the bird in its surroundings by working imaginatively with water, vegetation, and other ambient elements. You can also harness the power of still photography as a medium for suggesting movement.

■ **Discover uncommon perspectives.** As much as you want to get as close to birds as possible, you should explore what you can achieve from a distance. Experiment by looking up as birds fly overhead and by looking down as birds float below. Look from behind and through foreground shrubbery. Get into a boat or wade into water. You are sure to find new and unusual ways to portray birds creatively.

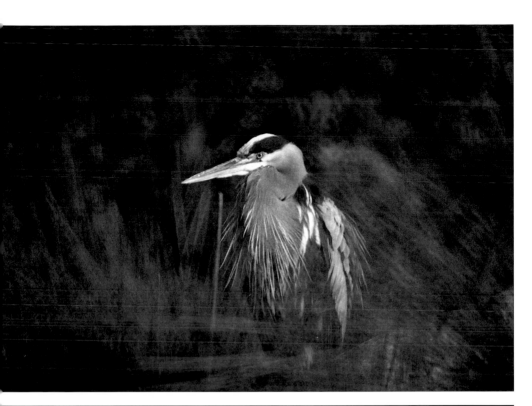

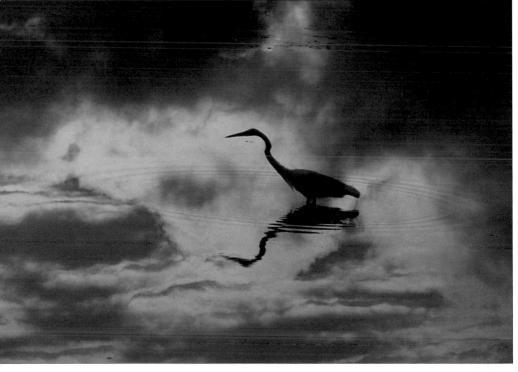

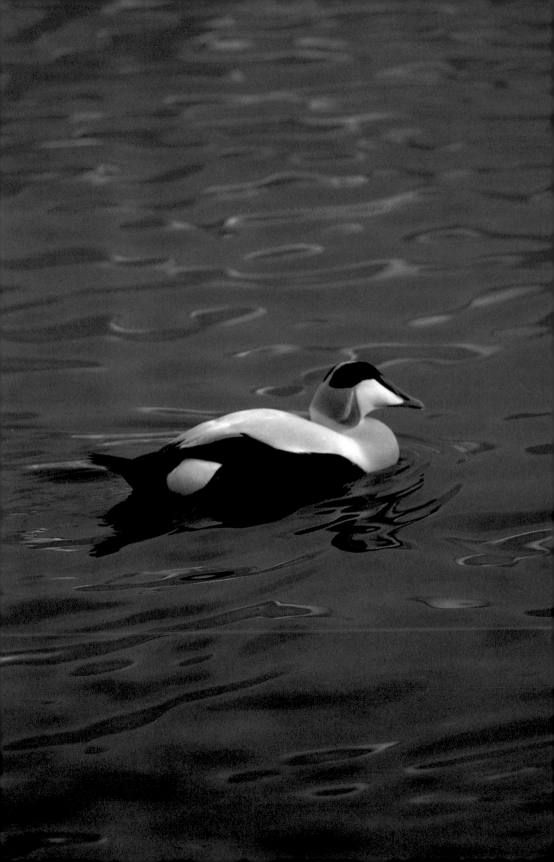

Selecting Equipment

I was on an assignment in Massachusetts, not expecting to photograph birds. When I saw this eider duck in the ocean, I used the longest telephoto lens I had with me, a Nikkor 300mm, to get a reasonably large image. To help create the impression that the frame is full, I used a vertical format. This also let me incorporate the shimmering colors on the water. Working with my Nikon F2, I exposed at f/4 for 1/125 sec. on Kodachrome 64.

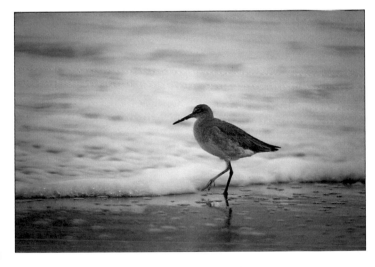

A built-in motorwinder or an add-on motordrive is an important piece of equipment for recording birds that are continually on the move. This sandpiper, which I came across on the California coast, was scurrying back and forth with each breaking of the waves. Thanks to my motordrive, I was able to rattle off a few shots in quick succession to get at least one good picture. With my Nikon F2 and my Nikkor 300mm lens, I exposed for 1/250 sec. at f/4 on Ektachrome 100.

Before you dash outside and begin stalking photographic trophies, make sure that your camera bag is properly equipped for bird photography. This relatively specialized field requires some gear that you may not have. But this doesn't mean that you should run out to the nearest camera shop and spend your money freely. First, you should evaluate what you can do with the equipment you already own. You should then plan to supplement what you have with a few well-chosen items that will let you get started in a serious way.

Today's sophisticated 35mm SLR cameras simplify bird photography. The Nikon N90, with its autofocus and autoexposure features, allowed me to capture this shot of a grebe in a Florida wetland. Without such built-in camera features, the image probably wouldn't have been as sharp, and I would have found it hard to gauge the complex lighting conditions with the bird swimming across the frame. Here, I used my Nikkor 300mm telephoto lens and exposed at f/5.6 for 1/250 sec. on Fujichrome 100 RD film.

After you've tried your hand at bird photography for a while, you can add items that will increase your ability to get the kind of shots you want but can't get with your current gear. If possible, borrow these items from friends or rent them before you make your purchase. This will give you a better sense of which features matter to you and are worth paying for and which aren't.

Remember, though, that equipment is supposed to serve your unique vision. By the end of this chapter, you should have a clear sense of what you need in your "photographic toolbox," as well as how each item can help you create the kind of bird images you can be proud of. The rest of the book will show you how to use each piece of equipment and develop your technical skills, so that you can successfully produce the images in your mind's eye.

CAMERA BASICS

One piece of equipment you can't do without is a single-lens-reflex (SLR) camera. For bird photography, the SLR camera must be a model with interchangeable lenses; if it isn't, your repertoire of shots will be limited. Medium-format cameras generally aren't recommended for this type of photography, and almost all point-and-shoot cameras are inappropriate for it. The only possible exceptions are the so-called "bridge" cameras, such as the Olympus IS-3, whose lens focal length can go up to 300mm with an added lens attachment.

This leaves you with a wide variety of 35mm SLR cameras to choose from. An SLR lets you fully control the technical and aesthetic aspects of your photograph. If you decide to get a sophisticated electronic SLR camera, you should choose one that provides override features, especially for manual focusing and shutter-speed selection. Don't be concerned about an autofocus feature. When you photograph birds, using this option is so hard that it actually becomes an impediment.

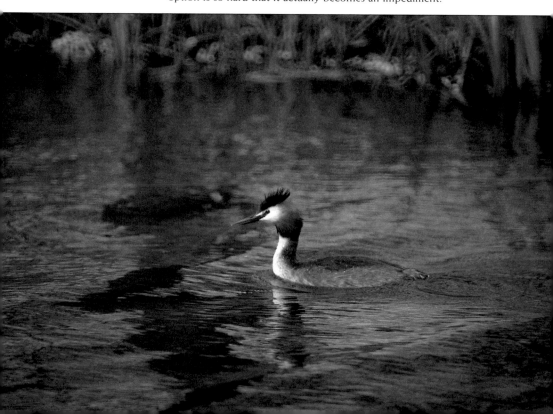

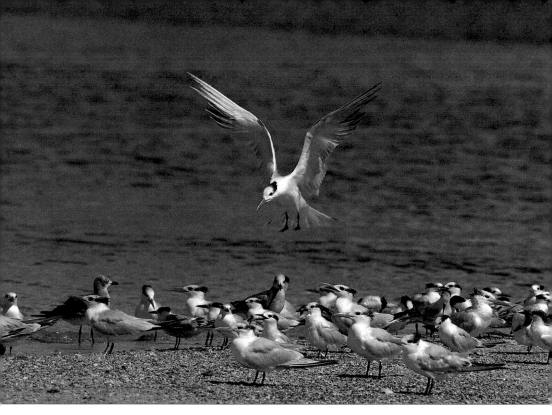

Be sure that the camera feels comfortable in your hands and that you can adjust the settings easily. This is particularly important if you must handhold your camera when you work with a heavy telephoto lens and need to quickly switch the settings in order to catch a bird's fleeting movements. You should also make sure that the camera's viewing screen is bright; this feature makes focusing easy. Some camera models even permit you to vary the viewing screens, so you can change them according to your needs.

While you look through the viewfinder, check the focusing mechanism. Many cameras come with split-image mechanisms, which work by aligning vertical lines. This process doesn't work well for bird photography, especially when the birds are small or far away. If you're buying a new camera, you should get one that has a clear Fresnel viewfinder. Here, if the image looks sharp in the viewfinder, it will be sharp on the film plane. If you have a camera with a split-image focusing mechanism, you should use the Fresnel portion of the screen—the part around the split-image circle—for focusing purposes.

A camera with an autoexposure feature, particularly one that is based on both center-weighted-metering and spot-metering mechanisms, comes in handy for bird photography. These are better than averaging- or matrix-metering mechanisms for this type of shooting because they let you home in on a bird and follow it with your camera without letting ambient or extraneous light adversely affect the exposure.

If you are in the market for a new camera, you should also consider a built-in motorwinder. This feature is perfect for the times when you need to rattle off a series of pictures in rapid succession. Nearly all recent SLR models have these motorwinders, which are almost as fast as true motor-drive attachments. Motorwinders produce 2 to 3 frames per second (fps) while motordrives produce 5 to 6 fps. And keep in mind that motor-

A camera with a very fast shutter speed makes the difference when split-second timing is needed. When I saw this flock of royal terns on the shores of Florida's Everglades National Park, I realized that the shot would be dull unless I could photograph one or more birds in action. I watched as they lifted off and landed, almost unpredictably. So I set the shutter speed at 1/1000 sec. and was able to record some shots like this one, even while handholding my Olympus OM-4T and Zuiko 350mm telephoto lens. Here, the exposure was f/2.8 on Fujichrome 100 RD film.

A telephoto lens with a focal length of 300mm was barely adequate to record this small cactus wren from only a few feet away. Since I was hiking into the back country in Big Bend National Park in Texas, I didn't want to carry my heaviest equipment. So I was lucky to be able to approach this skittish bird. My technique was to step and shoot, repeating the process until I got close enough for a reasonably good size image of the bird perched on a yucca. With my Nikon F2, I exposed Kodachrome 64 at f/4 for 1/500 sec.

By using my Zuiko 350mm telephoto lens from a close vantage point, I was able to fill the frame with this flicker at a backyard feeder. Shooting such close-to-home images are a good way to hone your photographic skills with a minimum of wear and tear. A wide-open aperture helped blur the background, producing a simple green wash of color that accentuates the textures of the bird and the seed. Here, I used my Olympus OM-4T and exposed Ektachrome 64 Professional EPX film at f/2.8 for 1/60 sec.

winders are lighter and easier to handhold than motordrives. If, however, you plan to use an older camera without a built-in winder, you can add a motordrive to increase your photographic options.

A wide range of camera models is available, and new ones frequently come out on the market in every price range. To keep up with the latest offerings, check a reputable photography magazine, such as *Popular Photography*. Staff members at these magazines often test new cameras and other equipment and explain the results, usually with visual backup.

LENSES

With a 35mm SLR camera, you can expand your visual repertoire with an array of interchangeable lenses. For establishing shots that show the scene and for special situations when you can get very close to birds, you should have a 50mm standard lens on hand. Wide-angle lenses have a place in bird photography, too. They are particularly helpful when you want to photograph birds in the broad context of their surroundings

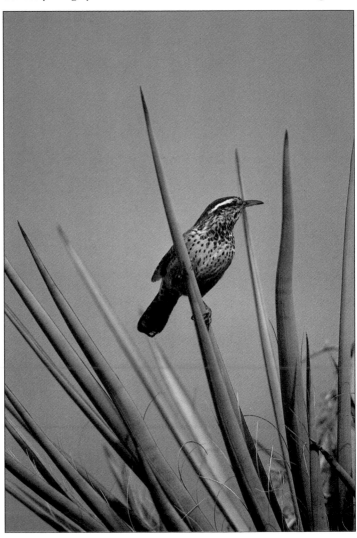

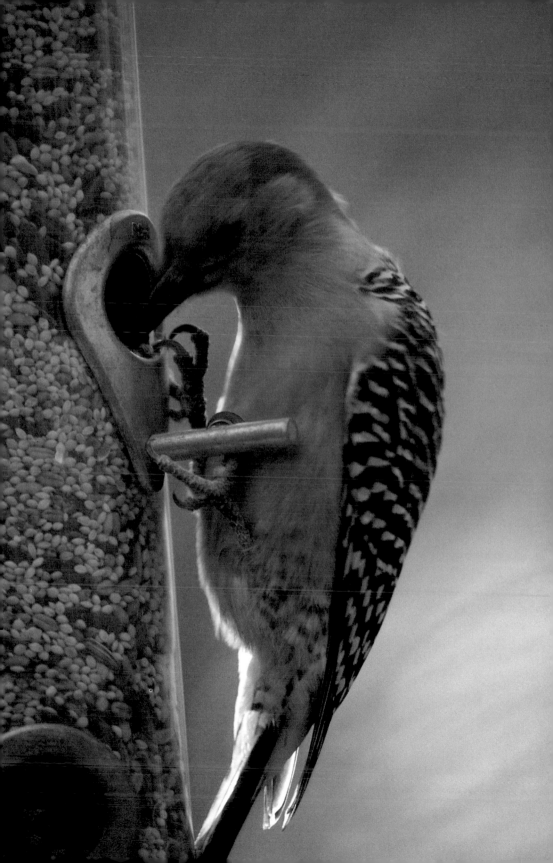

Working in Florida, I couldn't get closer than 20 feet to this small saw-whet owl. I needed my Zuiko 300mm lens to adequately magnify my subject. Although the bird is rather small and is shown against a visually jumbled setting, the shot does document the bird. With my Olympus OM-4T, I exposed for 1/125 sec. at f/4 on Kodachrome 64.

This photograph of a barred owl succeeds because the bird is large, and because I used a 1.4X tele-extender, which effectively turned my Zuiko 350mm telephoto lens into the equivalent of a 500mm lens. These factors created a bigger image and allowed me to blur the Florida background, which is flattering to the owl. With my Olympus OM-4T and Fujichrome 100 RD film, I exposed at f/2.8 for 1/125 sec.

without a loss of sharpness. Here, of course, the birds must be fairly large, and you must be able to get within a few feet of them.

In most shooting situations, however, you'll choose from among the range of telephoto and telephoto-zoom lenses. You'll want the fastest telephoto lenses you can afford; you may have to pay a premium for the extra speed. These lenses enable you to use the fastest possible shutter speeds for freezing movement and for working under dim light conditions. Fast lenses are also brighter to look through, so you can see your subjects more clearly and focus with greater precision. Telephoto lenses magnify small or distant birds. Keep in mind that even birds that are only a few feet away from you require magnification to adequately fill the frame. In general, it is easier to focus and get a sharp image when you get close and use less magnification than if you stay far away and rely on longer lenses. It is also more fun to look at the birds from the shortest possible distance.

As you shoot, remember that telephoto lenses can focus down only to a certain distance, generally 20 or 30 feet. At this distance, small birds will still be specks. But to work at shorter distances, you'll need extension tubes, which permit you to focus down to about 10 feet.

Telephoto lenses whose focal lengths range between 200mm and 600mm are the best choices for bird photography, although you'll probably encounter some professional bird photographers using lenses up to 800mm in focal length. If you can purchase only one lens, get a 400mm telephoto lens. You can combine it with a 1.4X tele-extender for increased magnification. Be aware that the stronger the magnification power of a telephoto lens, the harder it is to handle. As a result, you should always use a sturdy tripod to steady these heavy, bulky lenses.

If you don't want to change lenses when you're out shooting, you can try one of the many new telephoto-zoom lenses on the market. Their focal lengths typically range from 200mm to 400mm; some, however, go

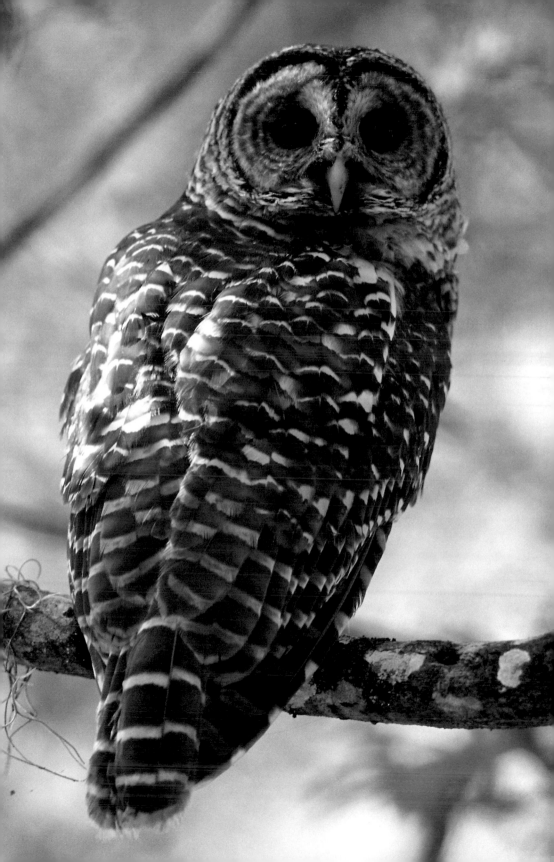

This swan, which I photographed with my Nikkor 50mm standard lens in New York City, fills the frame (top). The contrast in light and tonalities between the swan and the water enhance this simple portrait. I polarized the scene to heighten this difference. Shooting with my Nikon F2, I exposed for 1/60 sec. at f/5.6 on Kodachrome 64. For the vertical shot, I wanted to reduce the exaggerated curvature that I knew my Zuiko 18mm wide-angle lens would cause (bottom). Even with this shift in perspective, I was able to combine the swan, which was only a few inches from my Olympus OM-4T, with the distant landscape. The exposure on Fujichrome Velvia was f/8 for 1/125 sec.

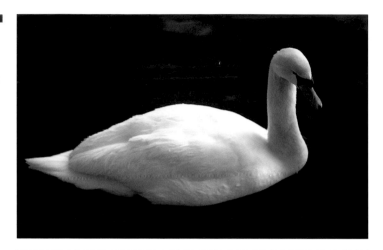

Because I was only 1 or 2 feet from this mute swan, I was able to use my Zuiko 18mm ultrawide-angle lens on my Olympus OM-4T to create an unusual image (opposite page, top). I wanted the lens' distorting effect to curve the perfectly flat Dutch landscape. The distortion also increased the apparent distance between the swan and me, thereby making the bird seem smaller than it actually is. The exposure on Fujichrome 100 RD film was f/5.6 for 1/125 sec. At Courrances, a French chateau, I chose my Zuiko 35mm wide-angle lens and worked from a distance of 5 feet (opposite page, bottom). Here, I wanted to depict the swans in their setting, including both banks of the serene canal. Shooting with my Olympus OM-4T, I exposed at f/8 for 1/125 sec. on Fujichrome 100 RD film.

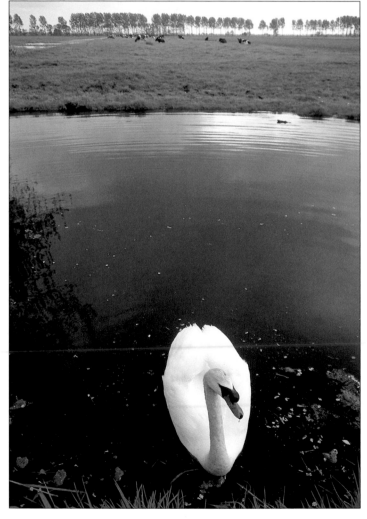

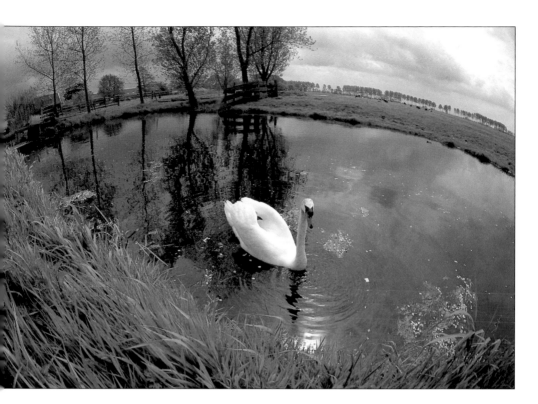

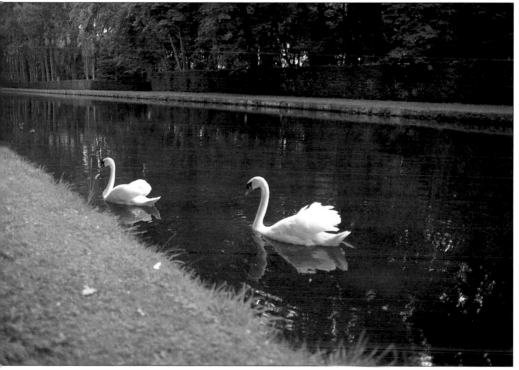

Even with a telephoto lens, I needed extra magnification to achieve a solid image of this great blue heron in Florida's Everglades National Park. The lens' limited depth of field at its widest aperture also served my purpose by slightly blurring the tangle of grasses behind the bird, even at a shooting distance of 50 feet. With my Olympus OM-4T, my Zuiko 350mm lens, and a 1.4X tele-extender, I exposed Fujichrome 100 RD film at f/2.8 for 1/500 sec.

This closeup shows the field marks of a California quail that I came across in Ohio. A wide-open aperture helped blur the background, so the bird is clearly delineated. This setting also permitted me to use a fast shutter speed, thereby freezing this bustling bird's movement. Shooting at a distance of 10 feet with my Olympus OM-4T and my Zuiko 350mm telephoto lens, I exposed for 1/500 sec. at f/2.8 on Fujichrome 100 RD film.

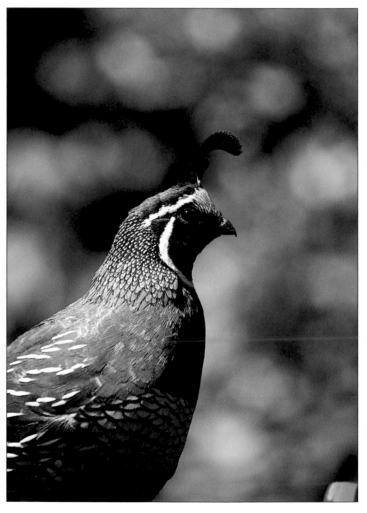

up to 600mm and don't exhibit any appreciable loss of sharpness. One such lens can take the place of several regular telephoto lenses, which makes for a lighter load. Naturally, this is a boon if you're traveling or hiking into an area. But keep in mind that any single telephoto-zoom lens is likely to be heavier and bulkier than any single telephoto lens. Another, even more important disadvantage of telephoto-zoom lenses to consider is that they tend to be slower, less bright, and harder to focus than their single-focal-length counterparts.

Telephoto lenses, with their limited depth of field, also allow you to isolate a bird from its surroundings by throwing the foreground or background portions of a scene out of focus. This feature enables you to set off a subject against a blurred backdrop, thereby separating the bird from its setting while retaining a sense of its habitat. Since birds are often found in areas with bright reflections, be sure to use the built-in lens shade to reduce glare and flare.

FILMS

Film choice can make a significant difference in the way your bird photographs look. In particular, it can affect clarity, sharpness, and color, elements that are important to the aesthetics of your final images. Since new films are being developed all the time, once again you should consult a reputable photography magazine, such as *Popular Photography*, to learn about and compare what is on the market. Fortunately, you have many excellent films to choose from. Keep in mind the following three major points when making your decision.

Film Speed. As a rule, you should choose the fastest possible film that won't adversely affect the sharpness of your images. Film speed plays an important role in bird photography because you may want to stop your subjects in motion by using a very fast shutter speed. If you also want to

Fujichrome 100 RD film delicately rendered the pale pastels in this monochrome image of a mourning dove. Here, I used my Olympus OM-4T and my Zuiko 350mm telephoto lens fitted with a 1.4X tele-extender, and exposed at f/2.8 for 1/500 sec.

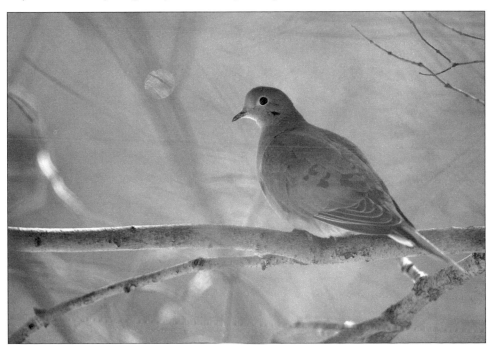

use a small aperture setting to maximize sharpness or you're working in low light, fast film can make the difference between a shot that you can get and one that gets away.

For this reason, you shouldn't choose Ektachrome 64 Professional EPX film or Kodachrome 25 for bird photography. Many professional photographers like them for their excellent color reproduction and fine grain structure, but these slow films don't let you successfully freeze bird movement. Keep in mind, however, that very fast films tend to reduce the clarity and sharpness of pictures. You can achieve a sharper image by pushing a medium-speed film than by working with a fast film that has a coarse grain structure. So stick to films rated ISO 100—Fujichrome Provia and Ektachrome Lumière are particularly effective— and push them to ISO 200 if you need extra speed.

Print Versus Slide Film. While choosing between print and slide film is mostly a matter of preference, color slide film is generally recommended

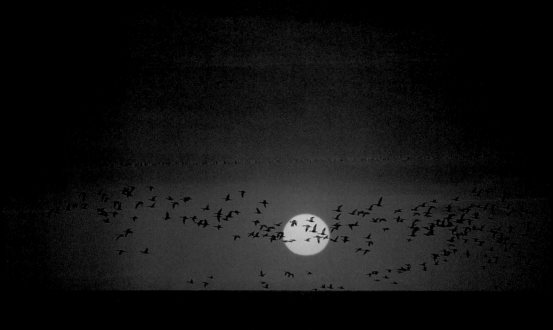

I made this shot of snow geese at New Jersey's Brigantine Wildlife Sanctuary. I found these birds particularly appealing because they were flying directly in front of the setting sun. Moving quickly, I framed the image with my Zuiko 50-250mm zoom lens and shot at 1/60 sec. to capture the moment. With my Olympus OM-4T, I exposed at f/5.6 on Fujichrome 100 RD film.

I selected Kodachrome 64 for this shot of a sapsucker poking its head out of its nesting hole in a tree in New York City. I based my decision on the combination of excellent sharpness and good color rendition in the reds and browns. Working with my Nikon F2 and my Nikkor 300mm telephoto lens, I exposed at f/4 for 1/250 sec. on Kodachrome 64.

for bird photography for several reasons. When you photograph birds, you inevitably shoot a lot of pictures, more than you would ever want to display or put in an album. Also, slide film costs less to buy and develop than print film. In addition, producing an enlarged print to frame is easy to do from a transparency. Finally, if you plan to submit your images for publication, be aware that most venues for editorial photography, such as nature magazines and books, prefer, if not require, slides.

Color, Grain, and Contrast. If rich color and fine grain for sharpness are important to you, you should choose one of the following slide films. Be aware, however, that they play to different strengths in terms of color. So for each shooting situation, you should select the film that best matches the colors you are likely to encounter when you photograph.

■ **Fujichrome Velvia**, although rated ISO 50, can be effectively pushed to ISO 100; it works especially well in low-contrast illumination, as well as in low light when the bird isn't moving.

■ **Kodachrome 64**, an old standby, was most photographers' film of choice for 30 years. It is still incomparable for rendering rich, warm colors with excellent sharpness. You can also successfully push Kodachrome 64 one stop, to ISO 125.

■ **Fujichrome Provia** produces vibrant greens and blues; it is also excellent for pastels in the cool hues. This film has an ISO rating of 100; has a fine grain structure, which results in excellent image sharpness; can be successfully pushed to ISO 200; and requires E-6 processing, which can be completed in just a few hours.

■ **Ektachrome Lumière**, with an ISO rating of 100, is a new film that compares favorably with Fujichrome films. Lumière is less contrasty than ISO 100 Fujichrome films, is as fine-grained as Fujichrome Velvia, and like Fujichrome films, uses E-6 processing.

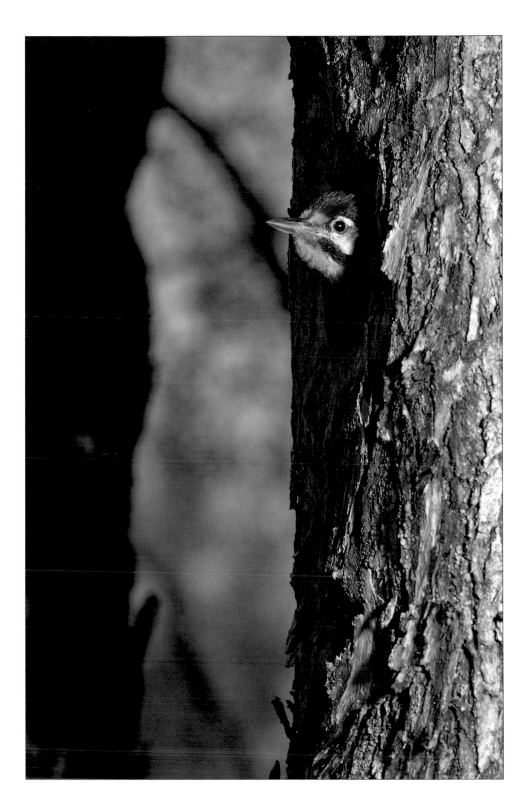

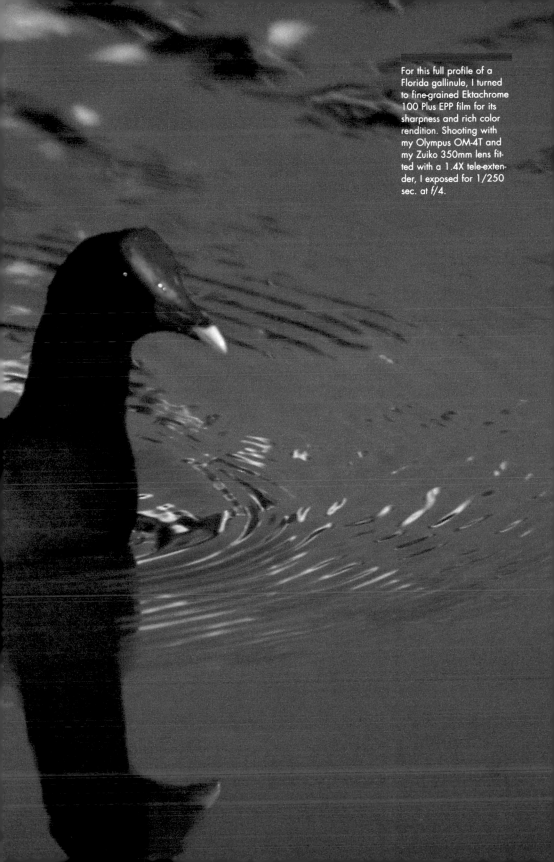

For this full profile of a Florida gallinule, I turned to fine-grained Ektachrome 100 Plus EPP film for its sharpness and rich color rendition. Shooting with my Olympus OM-4T and my Zuiko 350mm lens fitted with a 1.4X tele-extender, I exposed for 1/250 sec. at f/4.

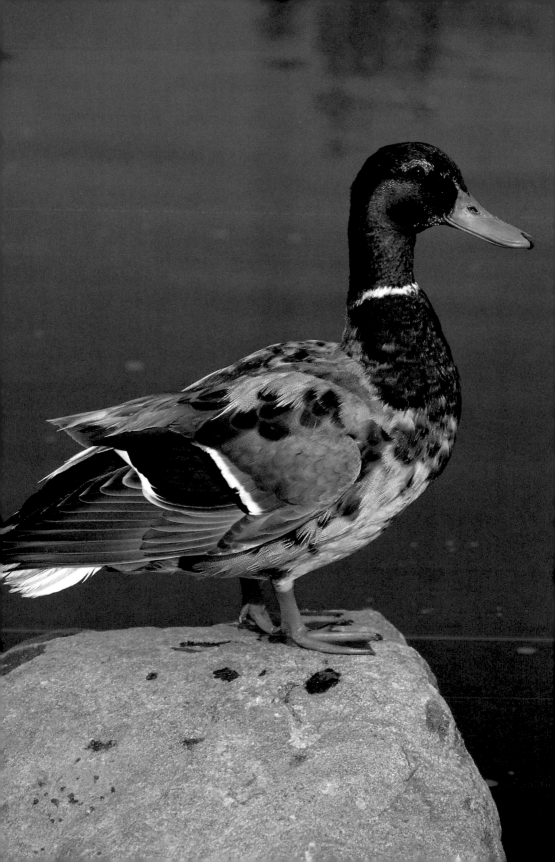

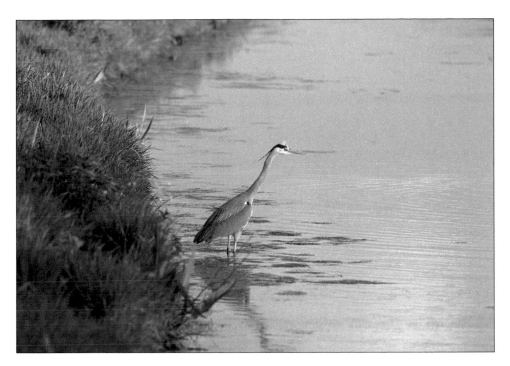

■ **Kodachrome 200** is an excellent warm-toned film. It produces beautiful results in low-light, low-contrast situations.

If you insist on using color-print film, try Fujichrome Reala and Kodacolor Gold 200. Both are fine grained and produce rich colors. Reala, however, has snappier greens and blues while Kodacolor favors warm yellows, browns, and oranges.

ACCESSORIES

For bird photography, you have an endless assortment of accessories to choose from, from those devices you really can't do without, to those gadgets that are useful, to those accessories that are just nice to have. The following discussion starts with the most essential items, such as a sturdy tripod, and moves down to those that are worth getting but that you can manage without.

Tripod. A sturdy, stable tripod, such as a Gitzo or Bogen model, is the most critical accessory for bird photography. It is an absolute must for keeping heavy telephoto lenses steady, so that camera vibration and movement are minimized. In addition, a tripod lets you set up a shot and maintain that position—no matter how long or how awkward—through a series of exposures.

Ball-Joint Head. A sturdy ball-joint head that maneuvers easily and locks with a single turn simplifies the process of using a tripod. Take a look at the Bogen, Foba, and Linhof Profi II and III models.

Quick-Release Plate. This device comes in two parts: one attaches to the bottom of your camera, and one to the top of the ball-joint head. This plate lets you remove your camera from the tripod in one quick motion in case you want to handhold the camera for a particular shot and need

A solitary great blue heron punctuates and the green grasses on the left enliven this otherwise bland scene in Holland. I used Fujichrome 100 RD film to slightly sharpen the green, which brightened the image as a whole. I made this shot with my Olympus OM-4T and Zuiko 300mm telephoto lens; the exposure was f/4 for 1/125 sec.

For this shot, I used Ektachrome 64 Professional EPX film because I wanted to take advantage of its fine grain structure, which produces a sharp image, and lush color rendition. The film's slow speed wasn't a problem because I was working in bright light, didn't need extensive depth of field, and the mallard was reasonably immobile. With my Olympus OM-4T and Zuiko 50-250mm zoom lens, I exposed at f/8 for 1/125 sec.

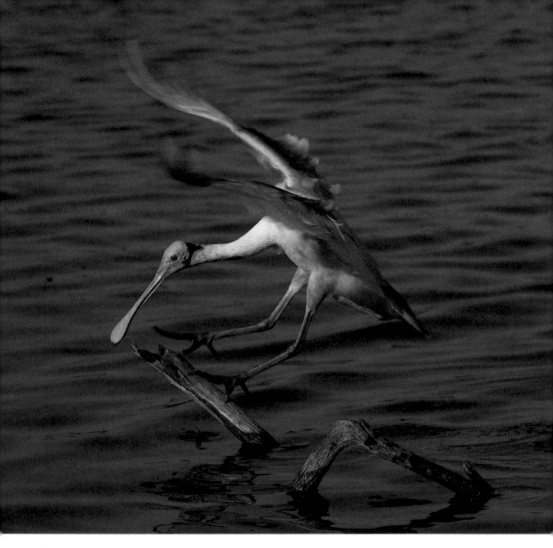

In this Florida wetland picture, I had a clear view of the roseate spoonbill as it came in for a landing. With the motordrive running, I simply panned the landing motion as my camera took a series of shots in quick succession. This particular image caught the spoonbill at the moment it touched down. the bird doesn't look all that graceful, but the shot is quite revealing. Working with my Hasselblad CM and Sonnar 250mm lens, I exposed Kodachrome 64 at f/5.6 for 1/250 sec.

to move to a new spot in a hurry. If you're working with more than one camera, put a quick-release plate on each one to facilitate speedy changes. And if you're working with long, heavy lenses, changing cameras can be faster than changing lenses.

Motordrive/Motorwinder. When you want to photograph birds on the move, a motordrive or a motorwinder is a must. These devices permit you to take several shots in rapid succession without having to manually advance the film and possibly jar the camera. Many new cameras come with a built-in motorwinder. If your camera doesn't have one, get an accessory motorwinder, which usually attaches to the bottom of a camera. Although a motorwinder is slower than a motordrive—2 to 3 fps versus 4 to 5 fps, respectively—a motorwinder is cheaper and lighter than a motordrive.

Tele-extenders. These glass lenses, which fit between the camera body and lens, multiply the focal length of the lens. They are an inexpensive alternative to buying long lenses. For example, a 200mm telephoto lens with a 1.4X tele-extender is roughly equivalent to a 350mm telephoto

lens, while the same 200mm lens with a 2X tele-extender has the magnification power of a 400mm telephoto lens.

If you're shooting at a relatively close range, tele-extenders also reduce the focusing distance of the lens somewhat; however, that isn't their main purpose. Keep in mind that tele-extenders reduce the light intake of lenses and are, therefore, appropriate only when you shoot in fairly bright light or when the bird is quite still.

Extension Tubes. If you are lucky enough to be within a few feet of the bird you want to photograph, you may need to reduce your focusing distance via the use of extension tubes. These hollow metal tubes attach between the camera body and lens and allow for closer focusing than the lens alone does. For example, if you photograph shorebirds at the beach, you may be able to get too close to focus with your 300mm telephoto lens. In this shooting situation, extension tubes will let you move in and get that special closeup. They come in a variety of lengths and can be purchased in a set of three, 7mm, 14mm, and 24mm long. You can combine extension tubes to fine-tune your focusing range.

Camera Bag. Lenses longer than 400mm in focal length may not fit into a standard camera bag; however, these lenses usually come with their own cases, which you can sling over your shoulder. Also, you are likely to leave one long lens on the tripod at all times, and carry them together as a unit as you move from one spot to another. But the rest of your gear should fit comfortably into a sturdy, light camera bag that has enough separate compartments for all of your gadgets. Look for easy, snap-together closure devices, which are more reliable than zippers and snaps, such as those made by Tamrac and LowePro.

Some photographers prefer the convenience of a photo vest or a fanny pack to a camera bag. These items come in handy when you plan

This dove was trying its best to hide among the fall foliage in an Ohio garden; however, I was determined to photograph the red leaves and white dove simply because they were such an odd color combination. Using the built-in electronic flash unit on my Olympus IS-3 point-and-shoot camera, I was able to illuminate both the bird and the bush. With my Zuiko 35-180mm zoom lens set at 70mm, I exposed at f/8 for 1/60 sec. on Ektachrome 64 Professional EPX film.

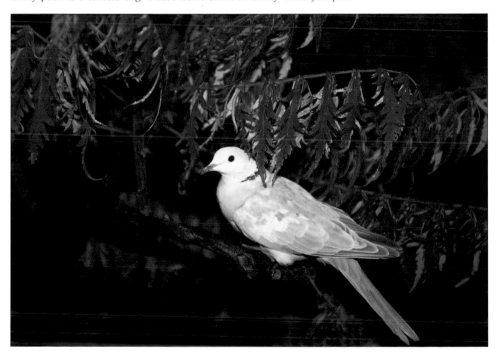

These mottled ducks were huddled under a coastal boulder, where the gray color of the rock seemed to dull the bright sunlight. My 81A warming filter came to the rescue. This basic accessory not only ensured that the image would contain the glow I actually saw, but also enhanced the ducks' yellow beaks. Shooting with my Olympus OM-4T and Zuiko 300mm telephoto lens, I exposed for 1/250 sec. at f/4 on Ektachrome 64 Professional EPX film.

to hike a distance to your destination and don't expect to carry much gear with you. But they aren't substitutes for a good camera bag.

Binoculars. The extra magnification that binoculars offer lets you see birds more clearly and from a greater distance than camera lenses. For birding, you should choose a pair of binoculars with 7X or 8X magnification. Be sure to select a model that you can easily adjust to your eyes and that is bright even in dim light. You might want to consider the small but powerful models that are on the market, which you can wear around your neck or put in your pocket.

Bird Guides. The staples in the bird-watching field are Roger Tory Peterson's *Field Guide to the Birds* and Golden Press's *Guide to Field Identification: Birds of North America* with illustrations by Arthur Singer. These are indispensable for identifying specific bird species when you are in the field.

Cleaning Kit. You should check your gear and clean it thoroughly right after each shoot, particularly if you've been photographing in areas with sand and water. By taking this precaution, surface dirt won't have a chance to settle in and cause serious or expensive damage. A small cleaning kit should contain the following: a soft cloth, lens tissue, and a bulb-type blower with a brush, not canned air. These items should take care of your ordinary cleansing needs in the field and between shoots. Use these cleaning tools gently to eliminate moisture and surface grime on your camera and lenses. (For stubborn smudges, breathe on your lens before wiping it with lens tissue.) Don't use these items, however, to clean the inside of your camera; a professional should do that.

Electronic Flash Unit. If you are within 20 feet of your bird subject and want to add fill light, use an electronic flash unit mounted on the camera

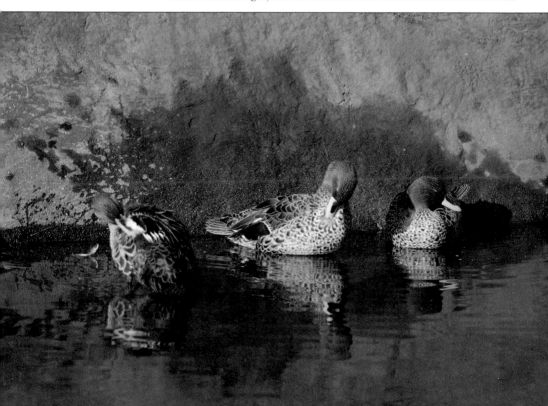

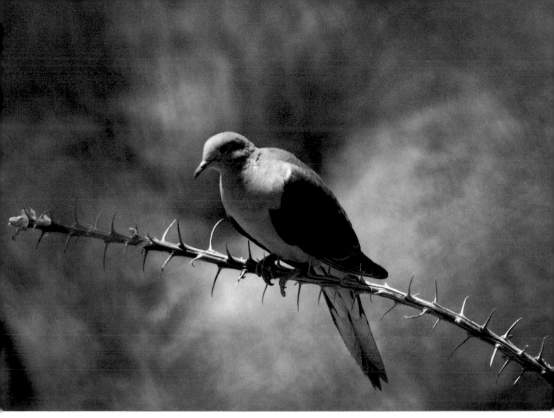

or held off the camera. You might want to try one of the new Fresnel flash screens that fits over the flash unit and narrows the beam of light, so that it acts as a spotlight aimed at the bird. The burst of light also helps to freeze the bird's movement, even when you're using a shutter speed of 1/60 sec.

Beanbag. This inexpensive device helps stabilize your camera when you brace it on, for example, a car, fence, or rock, rather than set up a tripod.

Car Brace. If you plan to use your car as a blind, you can mount your camera on a car brace with a ball-joint mechanism. This enables you to shoot from inside your car when you are in a wildlife refuge where birds are plentiful and close by.

Lens Shade. Most telephoto lenses come with a built-in lens shade, which slides forward to shield the lens. Be sure to use the lens shade to prevent extraneous rays of the sun from entering the camera. For other lenses, you need to buy a separate lens shade for each lens. Check carefully to make sure that the lens shade doesn't cause vignetting, which is the darkening of the corners where the lens shade is visible. This is a particularly important consideration when you use wide-angle and zoom lenses, as well as when you place the lens shade over a filter.

Handheld Spot Meter. This is a wonderful aid for pinpointing exposure readings, especially if your bird subject is at a fair distance and you face variable- or high-contrast lighting conditions. A handheld spot meter is also a good backup for checking the accuracy of your camera's built-in light meter.

Without a 2X tele-extender, I couldn't have created this image of a mourning dove in Arizona. The tele-extender effectively doubled the magnification power of my Zuiko 300mm telephoto lens. As an added bonus, the tele-extender helped produce an interesting backdrop by throwing the scene completely out of focus. With my Olympus OM-4T, I exposed Fujichrome 100 RD film at f/2.8 for 1/500 sec.

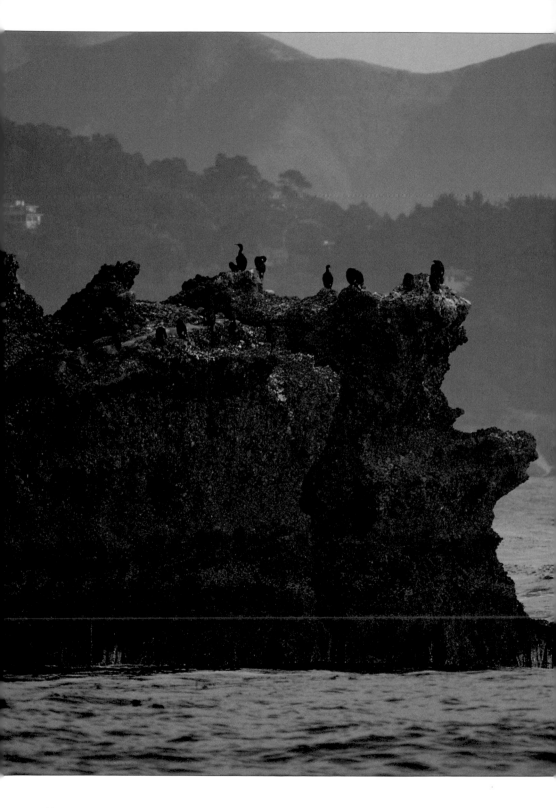

Polarizing Filters. These filters, which are also called polarizers, help remove reflections from foliage and water, and deepen the blue of the sky. You can control the amount of polarization you want by watching the filter's effect as you rotate it on your lens. Polarizers have limited use for bird photography because they reduce light intake by two f-stops. Also, polarizers that fit long telephoto lenses are expensive. If, however, you're photographing a white egret at close range at the water's edge on a very bright day, a polarizer may come in handy.

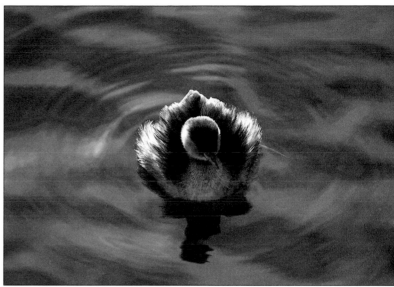

A tripod with a smooth ball-joint head makes bird photography less difficult. Here, I was able to stabilize my long, and heavy, Nikkor 300mm lens while waiting for the small grebe to get into position for the shot I wanted. I could easily follow the bird as it moved around, keeping it in the viewfinder without having to carry my Olympus OM-4T and my lens. When the grebe turned toward me, I was able to snap the shot without missing a beat. The exposure was f/4 for 1/250 sec. on Kodachrome 64.

I wanted to capture the picturesque quality of the California coastline near Monterey, where cormorants routinely congregate. But the fog and mist that are also regular visitors almost made it impossible for me to get the shot I wanted. Fortunately, I had my ultraviolet haze filter with me. It cut through the atmospheric interference enough to produce a clear image of the nearest rock formation. My tripod kept everything steady during the slow 1/30 sec. exposure. Shooting with my Olympus OM-4T and Zuiko 300mm telephoto lens, I exposed Kodachrome 64 at f/8.

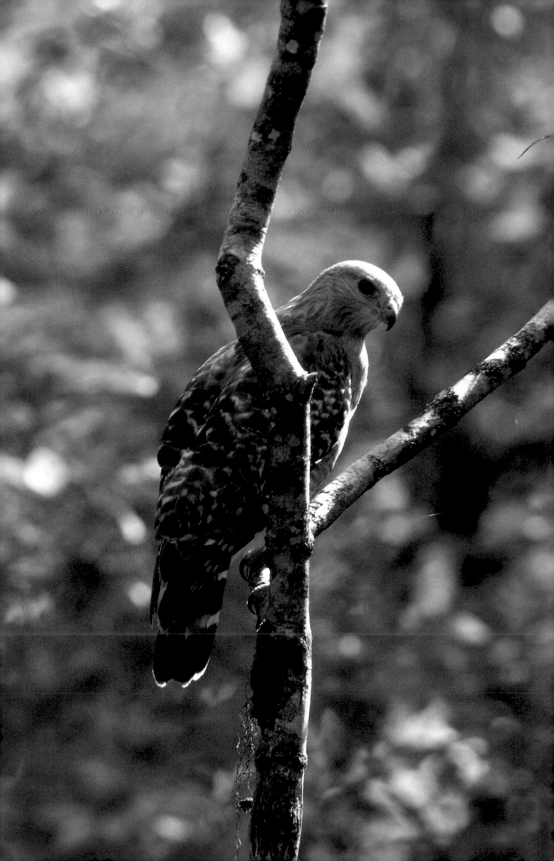

Mastering Field Techniques

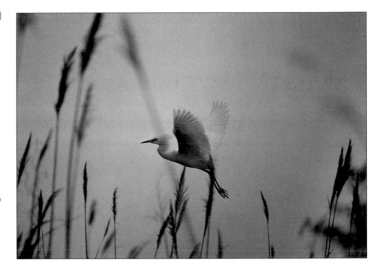

Seeing a Cooper's hawk is rare, so when I sighted one perched in a tree in Florida's Corkscrew Swamp, I wanted to get the best possible portrait. But the bird was well camouflaged. I hoped to blur the busy backdrop, not an easy task from 100 feet. Fortunately, the hawk remained fairly motionless for a few minutes, giving me time to mount my Olympus OM-4T and Zuiko 350mm telephoto lens fitted with a 1.4X tele-extender on a tripod. Next, I opened up to the widest aperture to separate the hawk from its surroundings. The exposure on Fujichrome 100 RD film was f/2.8 for 1/125 sec.

To add some interest to this Jones Beach, New York, scene, I crouched down so that the foreground grasses suggested the setting. With my Nikon F2 and Nikkor 20mm lens mounted on a tripod, I watched for every opportunity to capture these egrets during liftoff. Since egrets don't take off as quickly as some other birds, I was able to shoot after they were already in the air. Here, I captured the bird at its peak extension. The exposure was f/5.6 for 1/60 sec. on Kodachrome 64.

B ird photography is among the most challenging and demanding kinds of nature photography. More than most other kinds of wildlife, birds tend not to be particularly cooperative subjects. Many birds are rather small and generally shy, and keep their distance. They either hide among grasses, foliage, and high tree branches or camouflage themselves in other ways. Birds are most active at dawn and dusk, when the light is less bright. Finally, they don't stay still for long.

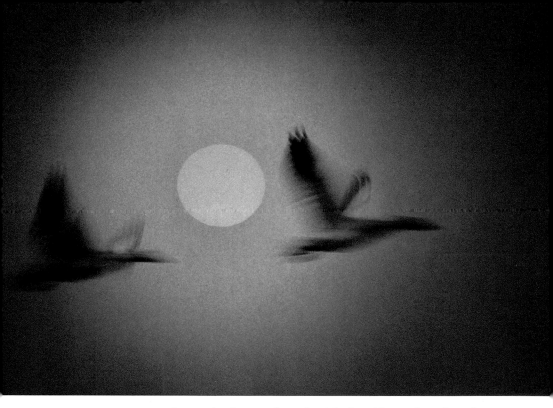

Even people who aren't bird enthusiasts marvel at the sight of snow geese in flight. I wanted to shoot a different kind of image of these birds during liftoff, and an opportunity arose by accident while I was at New Jersey's Brigantine Wildlife Refuge. The light was so dim at the end of the day that I was forced to use a slow shutter speed. I decided to try for an impressionistic blur of the geese and created one by panning at 1/15 sec. Then, because the sky was a boring backdrop, I combined the deliberate blur with a sunset shot I'd taken elsewhere. Working with my Olympus OM-4T and Zuiko 50-250mm zoom lens, I exposed Fujichrome 100 RD film at f/5.6.

As a result, photographers who defy the odds in order to bring home some visual trophies are often treated either with great respect or as if they are a little mad. No doubt, such photographers are dauntless. But the truth is that once you've experienced the exhilaration of getting a great bird image, you can't turn back. Even if you don't achieve all you would like to right away, the process of trying to shoot these images is truly mesmerizing and involving. In fact, some photographers have actually claimed that the attempt cleared their heads, like a lengthy meditation—or fishing—can.

One part of what keeps bird photographers going, of course, is the fascination with birds: their beauty, their charm, and their animated behavior. Another part is the photographers' desire to master the skill of specialized field techniques. There are no lucky shots in bird photography. Even the pictures that depend on luck or serendipity would never come to pass without a photographer's possessing the skills needed to capture these sometimes temperamental subjects. People rarely look at images of birds and think, "Big deal! I could have taken that shot."

This chapter covers these techniques in detail. Like any manual, however, these instructions are worthwhile only if you translate them into actions and then practice them to strive for perfection. The steps discussed here will get you started on the road toward such mastery. (Before you begin practicing, however, you should review the section on lenses in Chapter 2, so that your bird images will be adequate in terms of size.)

CAPTURING MOTION

The most difficult technique in bird photography involves portraying subjects in action. But as hard as this is, it is definitely possible, even without such complicated equipment as electronic triggers, beam splitters, and specialized flash equipment. The first consideration you have to

address comprises the range of actions you are likely to encounter and the strategies for handling them.

Essentially, two kinds of bird movements exist. One is the instantaneous type, which is often referred to as "the decisive moments"; Henri Cartier-Bresson, the great French photographer, coined this term. Instantaneous movements include such motions as taking off, landing, grooming, and feeding. The other type consists of continuous movements, such as flying, walking, stalking, and swimming. The smaller the bird and the more erratic the movement, the harder it will be to capture for you to record it on film. Fortunately, birds are predictable and tend to repeat themselves. If you watch them carefully, you should be able to anticipate their moves. The following techniques can help you capture these motions:

■ **Stop a movement.** The key to halting most motions is a fast shutter speed. Use shutter speeds from 1/250 sec. to 1/1000 sec., depending on how fast the bird is moving. You may not be able to get everything in the scene in focus, so aim to have the bird's head and eyes sharp, even if the wings aren't.

■ **Show a movement.** One way to record the impression of motion is to produce a deliberate blur by using shutter speeds as slow as 1/15 sec. The resulting evocative images provide a refreshing change of pace. Keep in mind, though, that you need to be selective about when to attempt this effect. It works better for broad, sweeping motions, such as wings flapping, than for small, jerky ones, such as grooming. A good way to try this technique is to find a bird's favorite perch, feeding ground, or nesting area and then work on recording takeoffs and landings using a slow shutter speed.

■ **Pan a movement.** This technique is another way to reveal a bird's steady, continuous movement. Panning involves following a bird with your camera as it moves smoothly in the same direction. Start by watch-

While on the island of Bonaire, I noticed a flock of warblers in the trees. These birds tend to flit from branch to branch, but they signal their departure with a telltale movement. Although I didn't have any special gear—no beam splitters or electronic triggers—I wanted to get a picture of this small bird in flight, so I tried to anticipate the bird's action. I framed the shot with my Zuiko 350mm telephoto lens while the warbler was on a branch about 25 feet overhead, leaving space for the takeoff. I needed split-second timing and luck to press the shutter-release button at the precise moment the bird spread its wings wide. With my Olympus OM-4T, I exposed for 1/250 sec. at f/2.8 on Fujichrome 100 RD film.

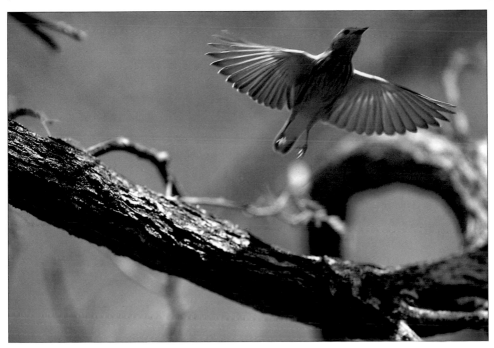

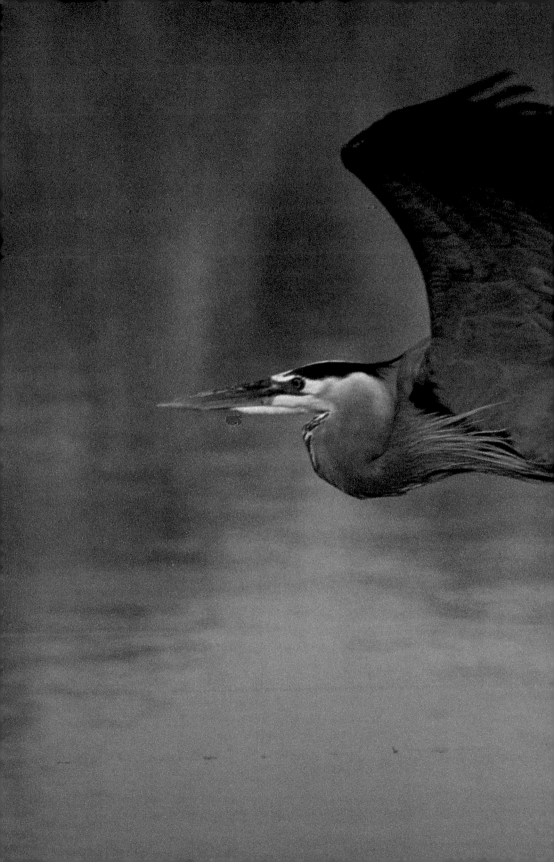

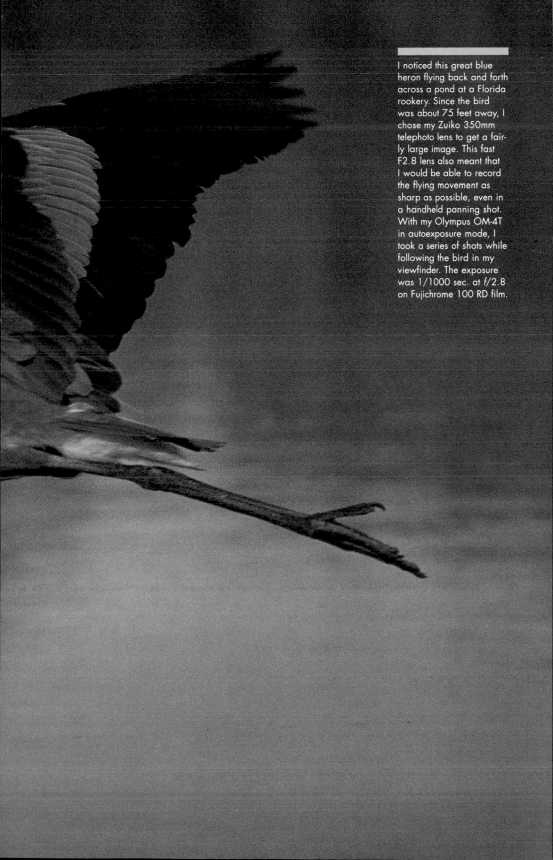

I noticed this great blue heron flying back and forth across a pond at a Florida rookery. Since the bird was about 75 feet away, I chose my Zuiko 350mm telephoto lens to get a fairly large image. This fast F2.8 lens also meant that I would be able to record the flying movement as sharp as possible, even in a handheld panning shot. With my Olympus OM-4T in autoexposure mode, I took a series of shots while following the bird in my viewfinder. The exposure was 1/1000 sec. at f/2.8 on Fujichrome 100 RD film.

ing for a pattern of the bird's movement, such as flying or swimming across the film plane. Handhold your camera, so that you can maneuver easily. If your camera doesn't have a motorwinder, turn on the motor-drive. Next, set your camera on autoexposure and aperture-priority mode, with the lens at its widest aperture. The camera will then select the fastest shutter speed possible under the available light conditions. Estimate where to focus, and wait until the bird is moving to fine-tune your focusing. Then follow the bird with your camera—that constitutes the pan—as it moves across the film plane, and press the shutter release while you pan. To keep your image sharp through several shots, repeat the focusing and firing steps as you continue to pan.

■ **Use fast lenses.** Since you want to use a fast shutter speed to stop movement, it helps to use fast lenses. It possible, these shouldn't be any slower than $f/5.6$. Preferably, they should be in the $f/4$ to $f/2.8$ range. The down side is that the fastest lenses are also quite expensive; a single fast lens can cost thousands of dollars. If you don't have or can't afford such lenses, you can compromise. Simply use the fastest lens you have, and compensate for its somewhat limited speed by using a fast film in the ISO 200-400 range, such as Fujichrome 400 or Ektachrome 400.

■ **Use fast films.** These enable you to select the fastest possible shutter speed. And they certainly are cheaper than buying the fastest possible lenses. But don't go to extremes when selecting film speeds. Since sharpness is a priority in bird photography, you should avoid the super-fast films, which tend to be too grainy. In general, stick with films rated ISO 100 and push them to ISO 200 if you need extra speed.

ADJUSTING TO NATURAL LIGHT

Natural light can be not only an ally but also a guide to making your bird photography pay off. If you are an experienced nature photographer, you are already apt to have an affinity for this kind of illumination. As you scout for subjects, remember to notice the main features of available light: direction, intensity, and color.

In addition, you must bear in mind that photographing birds calls for some special techniques. First, you can't make appointments with birds, so you have to meet them on their own turf during the seasons and at the times of day when they are likely to be visible. This may mean learning the seasonal and daily habits of birds in your region in order to know what to look for and when. This also may mean that you have to go out before dawn or stay on location until the last rays of the sun are gone. And this means being prepared to handle whatever light you encounter.

Early-Morning/Late-Afternoon Sunlight. Birds are most active at the extremes of the day when the sunlight is low angled and highly directional. This illumination also adds special beauty to the birds' surroundings. As a result, you should consider ways to depict the bird in its setting.

Sidelighting and backlighting are excellent for accentuating both the color and shape of a bird. Bright light coming from the side can spotlight a bird and set it off against a dark backdrop. In most of these situations, you simply take a spot-meter reading of the bird and then shoot at the reading. The only exception involves white birds; for them, you can underexpose up to one f-stop.

Conversely, backlighting enables you to silhouette a bird against a bright background. For backlit silhouettes, meter the background and shoot at the meter reading, bracketing toward underexposure at half-stop intervals up to one f-stop. Backlighting can also highlight the delicate

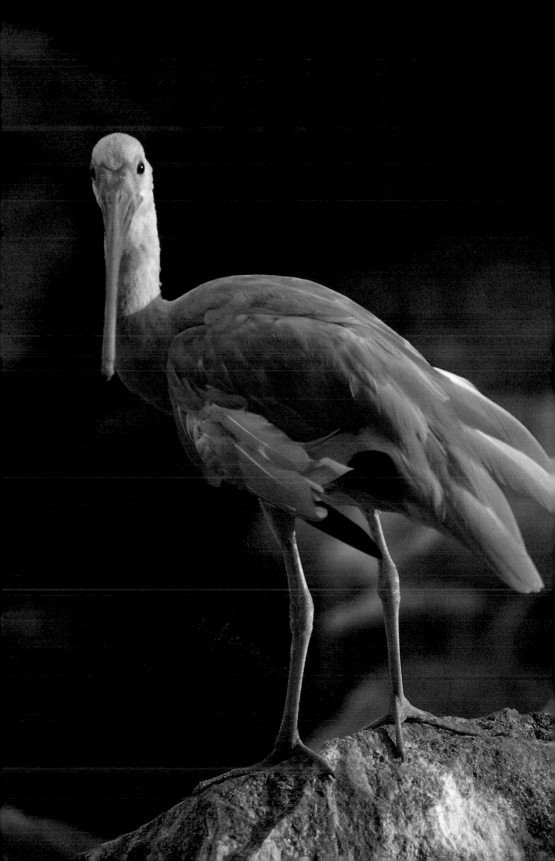

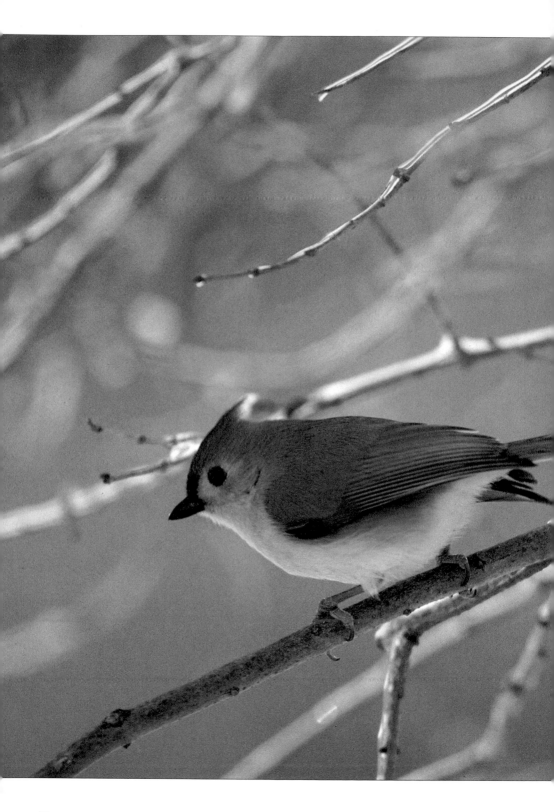

The nuthatch is a common backyard visitor, particularly if you have a feeder or a shrub that attracts these tiny birds. They are easiest to show in the muted, diffused light often found in winter. Working in this uniform, shadowless illumination, I adjusted my camera settings in advance by metering off a gray card, which is close to the color of the bird. Then I watched for it to land on a favorite perch before swooping down for a quick nibble, keeping my camera poised and ready for the moment when the nuthatch landed. With my Olympus OM-4T and Zuiko 350mm lens fitted with a 1.4X tele-extender, I exposed at f/2.8 for 1/500 sec. on Fujichrome 100 RD film.

Bright overcast illumination turned out to be just what I needed to bring out the intricate texture of this Mandarin duck, photographed at the Bronx Zoo in New York. The light not only provided enough illumination so I could use a small aperture for added sharpness, but also enriched the bird's colors and contributed to the bands of reflection in the water. Here, I used my Nikon F2 and Nikkor 200mm lens and exposed Kodachrome 64 at f/8 for 1/60 sec.

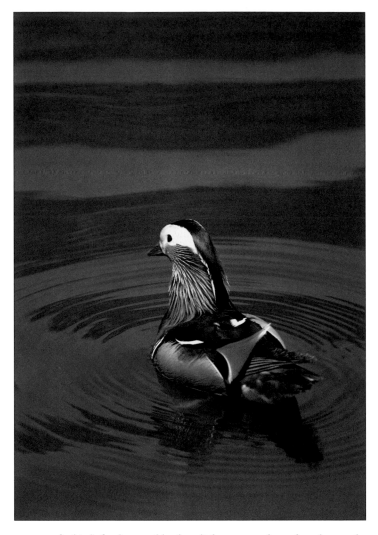

texture of a bird's feathers and beak as light streams through and around them. To achieve this effect, take a meter reading of the bird and shoot at that reading. Here, you can bracket half a stop toward overexposure.

Midday Sunlight. You won't have much luck finding birds in the middle of the day, but it isn't completely out of the question. Your best chances are with birds that flock together or congregate in open areas. For example, look for wading birds and shorebirds wherever you come across water. Also, you can attract backyard birds throughout the day via the use of feeders. This is a particularly effective strategy when winter sets in.

Midday sunlight has distinct advantages. First, it enhances bright colors. And because you can use a small aperture to maximize sharpness, this form of illumination brings out textures. It is also ideal for shooting movements that require fast shutter speeds. Whenever possible, be sure your bird subject is fully bathed in light. Besides images that are too small, the most disturbing elements of bird photographs are patches of shadows on the bird, especially on the head.

Midday illumination is particularly flattering for bird portraits—if you are close enough to get them. Take a spot-meter reading of the bird to avoid an exposure based on ambient light behind the bird. Try to frame your subject against a shadow or dark foliage that you can blur out rather than a blank sky or a bright, splotchy backdrop.

Uniform or Shadowless Light. Birds don't mind rainy days. But photographing birds is difficult enough in good weather, so unless you are a die-hard, you'll probably want to avoid going out when it is wet. However, the uniform illumination of an overcast day can be a real boon. This soft, shadowless light brings out subtleties in color and texture and is excellent for portraying stationary birds. Even on sunny days, you can find patches of uniform light in shadow areas. Of course, making the most of natural light goes hand in hand with achieving proper exposure.

EXPOSING WITH ACCURACY
Before the advent of cameras with autoexposure features, accurately determining exposure for bird photographs was quite a chore. Since birds are typically photographed from a distance, they were hard to meter. And to complicate matters even further, birds are often surrounded by bright areas of sky or water, thereby creating high-contrast lighting conditions that are difficult to handle. In addition, their movements frequently transport them from out of one kind of light into another within the span of several seconds. Obviously, all of these exposure-determination factors had the makings of a wild-goose chase.

Autoexposure capabilities have simplified matters considerably, although manual exposure is preferable at times. For the best possible exposure, nothing beats careful metering, manual setting of the aperture and shutter speed, and liberal bracketing. But the times when you can follow all these procedures aren't high in number; in fact, they're limited primarily to situations when your bird subject is reasonably still. So, if

Pictures taken against a bright blue sky are quite difficult to expose perfectly. While photographing this common tern hovering above New York's Jones Beach, I realized that I wouldn't achieve proper exposure on all parts of the bird. Some of them were brightly illuminated, and others were in shadow. I decided to concentrate on exposing for the well-lit features, especially the eye and the beak, and to get backlighting on the feathers to bring out details. I took a spot-meter reading of the bird's underside and then overexposed by 1/2 stop. Next, I filled the frame with the tern using my Nikkor 300mm telephoto lens and polarized to deepen the blue of the sky and increase the contrast between the bird and the background. With my Nikon F2, I exposed at f/8 for 1/250 sec. on Kodachrome 64.

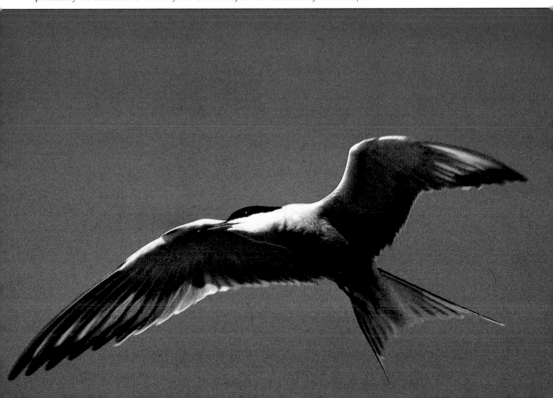

Brief amounts of time can change lighting conditions enough to make a difference in both exposure and the kind of image you can produce. I first glimpsed a great blue heron, standing on the bank of a canal in Holland, in fairly contrasty illumination. The light on the bird was diffused, but the light on the water was much brighter, causing the backdrop to appear nearly white (top). Although the heron looked fine, the background was quite unappealing. I exposed the scene by metering the heron and shooting at the indicated reading. With my Olympus OM-4T and Zuiko 50-250mm zoom lens, I exposed Fujichrome 100 RD film at f/5.6 for 1/125 sec. A few moments later, the sun went behind a wispy cloud, and the light became more uniform and subdued (bottom). It was the same bird in the same setting, but what a difference in the image. Less light was bouncing off the water, and the light on the flowering shrub was better than before. Once again, I metered the bird and shot at the suggested reading. Using the same camera, lens, film, and aperture, I simply switched to a shutter speed of 1/60 sec.

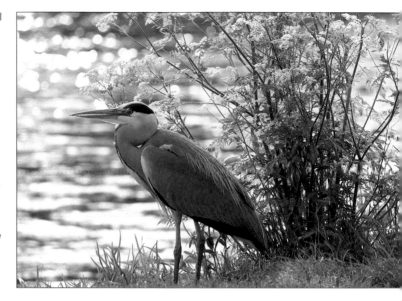

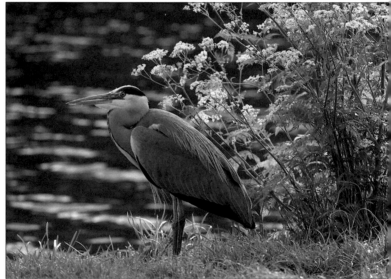

you see a sitting duck, take advantage of the situation and get that optimal exposure. At other times, you should make the most of autoexposure.

Of course, if your camera doesn't offer autoexposure features, you have little choice. In this case, your strategy will depend on whether you're trying to freeze movement or you're working with a stationary subject. If the bird is moving or if you're handholding your camera, start by presetting your shutter speed using the following rule of thumb: The shutter speed should roughly equal the focal length of the lens you're using. For example, you would preset a shutter speed of 1/250 sec. for a 200mm telephoto lens, and a shutter speed of 1/500 sec. for a 500mm telephoto lens. Your next step would be to base the aperture setting on a meter reading of the expected background. If a bird is much darker than the background and you don't want a silhouette, you would overexpose

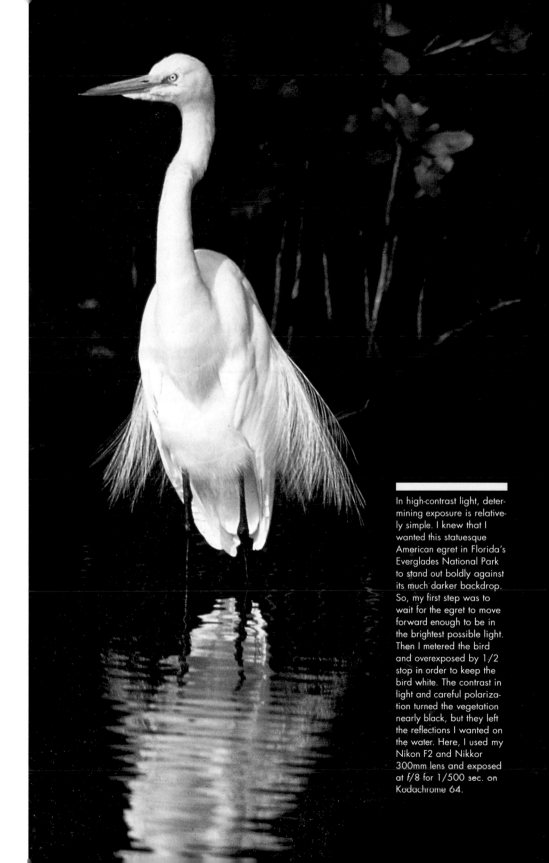

In high-contrast light, determining exposure is relatively simple. I knew that I wanted this statuesque American egret in Florida's Everglades National Park to stand out boldly against its much darker backdrop. So, my first step was to wait for the egret to move forward enough to be in the brightest possible light. Then I metered the bird and overexposed by 1/2 stop in order to keep the bird white. The contrast in light and careful polarization turned the vegetation nearly black, but they left the reflections I wanted on the water. Here, I used my Nikon F2 and Nikkor 300mm lens and exposed at f/8 for 1/500 sec. on Kodachrome 64.

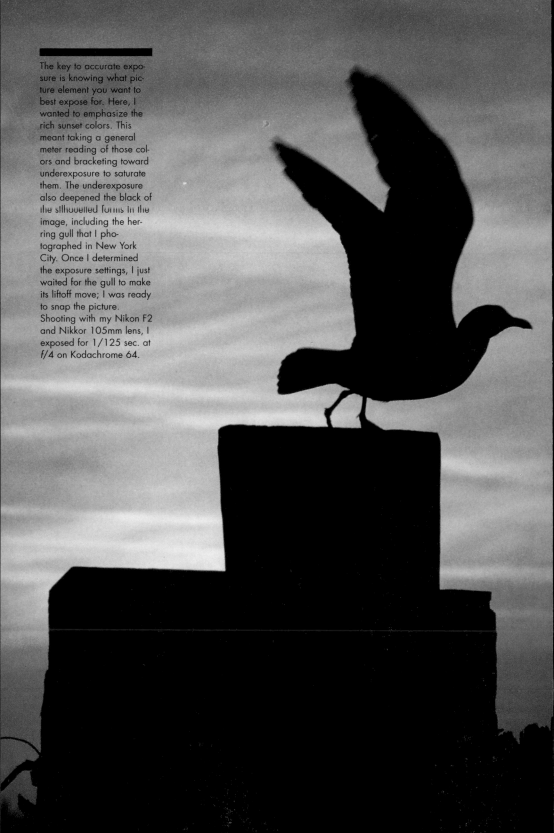

The key to accurate exposure is knowing what picture element you want to best expose for. Here, I wanted to emphasize the rich sunset colors. This meant taking a general meter reading of those colors and bracketing toward underexposure to saturate them. The underexposure also deepened the black of the silhouetted forms in the image, including the herring gull that I photographed in New York City. Once I determined the exposure settings, I just waited for the gull to make its liftoff move; I was ready to snap the picture. Shooting with my Nikon F2 and Nikkor 105mm lens, I exposed for 1/125 sec. at f/4 on Kodachrome 64.

Getting a bird in sharp focus isn't always hard, even when it is moving. This often depends on the speed and flow of the motion. For this shot of an American egret, its gliding movement some 30 above Jones Beach in New York didn't cause focusing problems. Since the details in its widely spread wings fascinated me most, I focused on them as precisely as I could, as I followed the bird's slow drift with my Nikkor 200mm lens. The fast shutter speed of 1/250 sec. stopped whatever movement was still evident. Here, I used my Nikon F2 and Nikkor 200mm lens. The exposure was f/4 for 1/250 sec. on Kodachrome 64.

up to one f-stop. If, on the other hand, the bird is much lighter than its surroundings, you would underexpose up to one f-stop.

If, however, your subject is stationary and your camera is mounted on a tripod, you would use a spot meter or your center-weighted built-in meter to accurately gauge the light on the bird. You would then be sure that the bird fills a good part of the frame. If this isn't the case, you would need to take a separate reading of the backdrop.

You now have two questions to consider: How bright is the bird compared to a neutral 18-percent gray card? And how bright is the bird relative to its surroundings? If the bird is lighter than neutral gray, you would overexpose up to one f-stop. If the bird is darker than neutral gray, you would underexpose up to one f-stop from the meter reading. Also, if the bird doesn't fill the frame and the surroundings are brighter than the bird, you would shoot at the center-weighted meter reading. But if the surroundings are darker than the bird, you would underexpose up to one f-stop from a general, center-weighted meter reading.

ACHIEVING SHARPNESS

Sharpness is vital to most bird photographs—to reveal the subject's details. These include their eyes, feathers, and beaks. Unless you deliberately and thoughtfully choose not to focus sharply, a lack of clarity can ruin an otherwise fine result. You can achieve extensive sharpness several ways.

Precise Focusing. The single, most important point to focus on is a bird's eye. Viewers can tolerate some lack of clarity in the bird's wings or other body parts, but the eye should be in sharp focus and, if possible, have a glimmer of light. Next in line is the bird's beak. The most effective way to render the beak sharp is to photograph the bird in profile. And keep in mind that a bright viewfinder makes it easier to achieve precise focus. Remember, if your camera has a split-image focusing mechanism, you

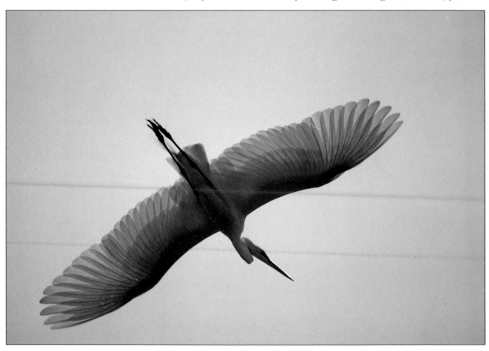

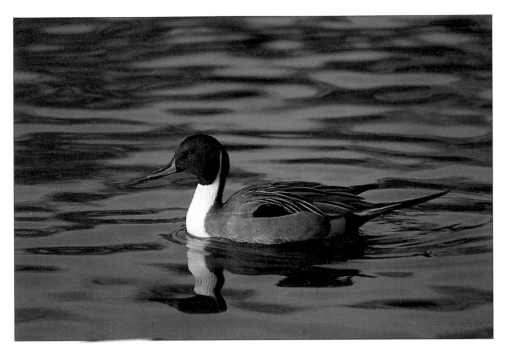

may find it hard to use for bird photography. So, you must look carefully at the Fresnel area around the split-image circle to determine if your subject is truly sharp.

Stopping Movement. In bird photography, movement is the biggest obstacle to sharpness. First, your equipment may be vibrating or unsteady. You can minimize these problems by mounting your camera on a tripod, which you should do for nearly all bird photography. Also, the wind may cause your camera to shake, and these small movements will be magnified if you're using a telephoto lens—which you probably are. Finally, of course, your subject is most likely moving.

For all of these reasons, you should generally use the fastest shutter speed you can for proper exposure. Even if you lose some sharpness based on depth of field, you are better off opting for a fast shutter speed. A blurred image is of little use, even if it has great depth of field. To stop most movement, you need a shutter speed of at least 1/250 sec.; slower speeds may be adequate for some panning situations and for slower motions.

Adequate Depth of Field. Depth of field refers to the area of greatest sharpness that extends forward and backward from an image's focal point. The smaller the aperture setting, the greater the resulting depth of field. Depth of field is most important for conveying sharpness, such as in the texture of a bird's feathers, and for imparting a three-dimensional look to your images.

But if you're shooting a subject farther than 50 feet away with lenses up to 300mm in focal length or farther than 90 feet away with lenses greater than 300mm in focal length, depth of field isn't a concern. Use the smallest aperture you can, but give greater consideration to your shutter speed. Remember, the aperture setting works together and recip-rocally with your shutter speed to control exposure. Also, your depth of field affects the way the backdrop is rendered.

Critical focus was essential to this shot of a pintail duck swimming in a New York bay. If the image weren't tack sharp, the pattern and texture of the bird's back feathers would have been lost, and its trademark pintail wouldn't show. Fortunately, the duck wasn't too active the day I was shooting. I managed to focus precisely using my Nikkor 300mm telephoto lens. A fairly small aper-ture setting extended the depth of field, and a fast shutter speed froze most of the bird's motion. Shooting with my Nikon F2, I exposed Kodachrome 64 at f/5.6 for 1/250 sec.

I needed every trick in the book to create this image of a little green heron in Florida; achieving sharpness was just one of the challenges. I had to work quickly to find a good perspective for this shy, reclusive bird, or it would have been gone before I fired off any shots. Even with my Nikkor 300mm telephoto lens, I wasn't able to fill the frame with the bird, so I opted for a view that incorporated the immediate surroundings. To ensure a sharp image, I used a fast shutter speed in case the bird moved and a fine-grained film, and focused precisely. The contrast in light between the foreground and background also increased the appearance of sharpness. With my Nikon F2, I exposed at f/4 for 1/250 sec. on Kodachrome 64.

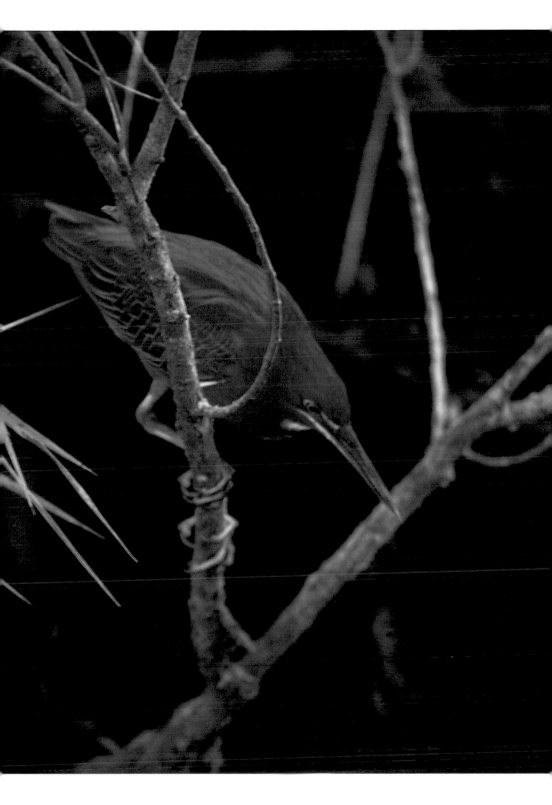

You can get a sense of how extensive depth of field is by pushing the depth-of-field preview button on your camera. This button closes down the aperture to the setting you chose. But if the natural light is dim, you may lose too much brightness in the viewfinder to see the actual results.

High-Contrast Light. A difference of more than two *f*-stops in the brightness levels of a bird and its surroundings can help to suggest sharpness in an image. This is because the edges between the light and dark areas are well defined. To enhance this illusion, take a meter reading of the dark part and underexpose one to two *f*-stops.

DEFINING THE BACKGROUND

How a photograph depicts the background behind a bird can make or break the image. A backdrop that fails to adequately complement a bird can undermine an otherwise fine photograph. As you evaluate the balance between your subject and its surroundings, you should keep in mind some helpful techniques.

Show the Full Setting. It is possible, and it certainly is informative, to portray your subject in the context of its natural habitat. If you can't get close enough for a full shot of a bird, you may have to find an imaginative way to incorporate the setting. If you can approach your subject, you may still want to include part of the setting. For example, you'll find that swans, ducks, and gulls are much less skittish than most other birds and permit you to photograph them from relatively short distances. Experiment with every type of lens, from a wide-angle lens to a moderate (100mm) telephoto, to see just how much of the environment works well with the bird you're photographing.

To keep the entire scene as sharp as possible, use a small aperture, such as *f*/8 to *f*/16, to achieve maximum depth of field. The farther you are from the bird, the less critical depth of field becomes. Even if you want the bird's environment to be visible and integral to the image, be sure the bird is set off from the background. You can do this via a contrast in light, color, or sharpness. Without such a separation, the bird loses its identity, and its features are lost in the vastness or confusion of competing elements in the frame.

A downward perspective from the water's edge in Holland made it possible for me to limit and simplify the backdrop behind this duck. The deep green water, punctuated by muted suggestions of the clouds overhead, is both interesting and unobtrusive, keeping the viewer's eye firmly focused on the bird. Shooting with my Olympus OM-4T and Zuiko 35–70mm zoom lens, I exposed for 1/125 sec. at f/8 on Kodachrome 64.

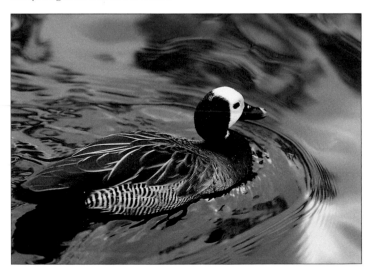

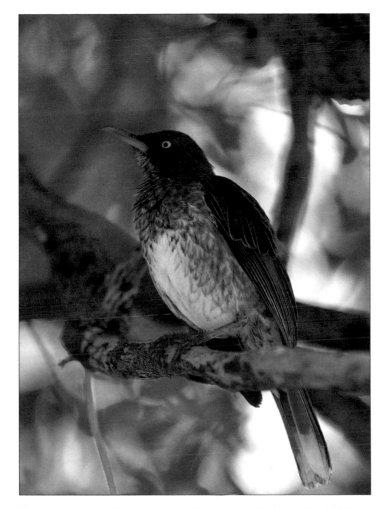

Combining a long lens and a wide-open aperture setting enabled me to limit depth of field in this shot. As a result, the jumbled background behind this bird in Bonaire became a blur. Here, I used my Olympus OM-4T and my Zuiko 350mm lens. The exposure was $f/2.8$ for 1/250 sec. on Fujichrome 100 RD film.

Limit the Setting. If you can get fairly close to a bird, you should fill a significant portion of the frame with it. However, you should also give viewers a glimpse of the bird's environment. For example, show the grasses, foliage, or branches around a bird. Be sure to compose carefully, so the setting frames the bird without overwhelming it.

How much of the setting you include depends on two factors: how close you can get to the bird and which lens you choose. If you can't get close enough to fill the entire frame with your subject, use your telephoto lens to get the largest bird image possible. The smaller the bird and the farther you are from the subject, the more magnification you'll need. For example, even with a powerful 500mm telephoto lens, you would have to move within 15 feet of a tiny nuthatch to have it fill just half the frame. But a larger bird, such as a heron, could easily fill half the frame if you were within 40 or 50 feet and were using the same lens.

Once again, remember to provide contrast between the bird and its immediate surroundings by incorporating a difference in color, light, or sharpness. You have greater control over these elements the closer you get to your primary subject, so move around as time permits and find a perspective that provides the contrast you need. For example, set a

brightly illuminated bird against a dark shadow, or a gray bird against green foliage. If these contrasts aren't feasible, blur the backdrop to effect a contrast in sharpness.

Simplify the Setting. If you don't want anything to distract viewers from your subject, try using a simple, natural backdrop of grasses or other uniform vegetation. Such nearly blank backdrops as water and sky put the spotlight on the bird. But because these images aren't the most interesting, don't rely on this technique excessively.

Water photographs best on overcast days. When you shoot in bright light, look for any hotspots on the water, and avoid them by changing your perspective. The sky is most appealing on clear, sunny days, and you may want to polarize to deepen the blue color of a bright sky. If you have no choice but to shoot against an overcast sky, which isn't an appealing prospect, try an overexposed shot and later combine it into a "sandwich" with another, more dramatic backdrop for the bird (see Chapter 6).

Throw the Backdrop Out of Focus. A clever technique for simplifying the backdrop is to limit depth of field. This enables you to keep the bird in sharp focus while turning the area behind it into a wash of color. This is an excellent way to eliminate distracting or competing elements in the background, which can be anything from foliage and twigs to cars and lampposts. If the bird and backdrop are roughly the same color, the blurring helps define the bird and delineate it from its surroundings.

The longer the lens and the more wide open the aperture, the more blurring you'll get. So you should use the widest possible aperture on your lens. You can see the blurring effect as you look through your viewfinder, which is open to the maximum setting. If possible, use a long lens to produce a shallow depth of field.

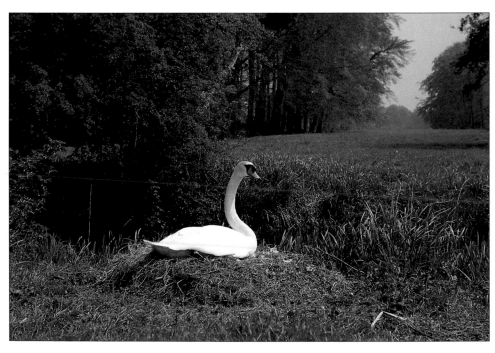

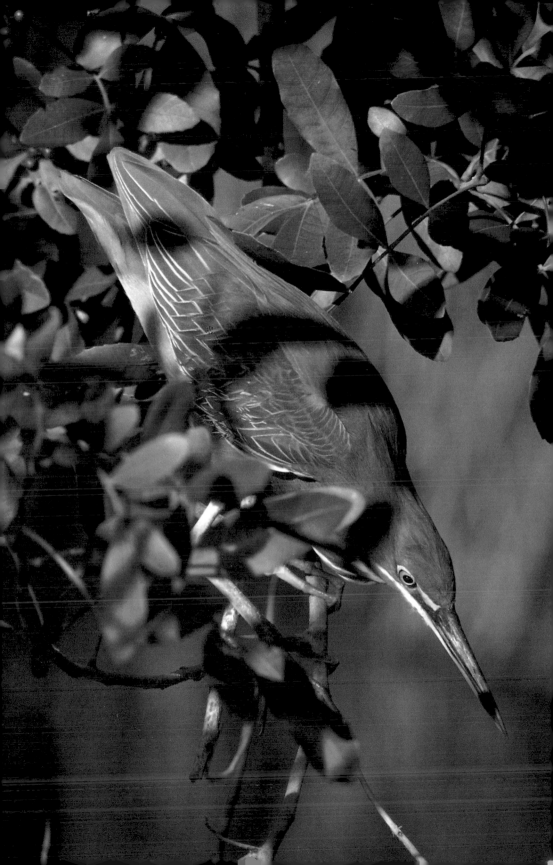

Composing with Purpose

During a trip to Thailand I hoped to shoot some magnificent bird images at a bird sanctuary, but my guide didn't realize that arriving at 10 A.M. was a problem. The sky was so bright that it was white, and the storks were in shadow or against the unattractive sky. I decided to shoot silhouettes and to add color and background interest later by sandwiching two slides. When I got the bird images back, I searched through my sunset shots for one in which the sun's disk fit nicely into the space I'd prepared. Shooting with my Olympus OM-4T and Zuiko 350mm telephoto lens fitted with a 1.4X tele-extender, I exposed Fujichrome 100 RD film at f/2.8 for 1/500 sec.

I had only a few moments to get this shot of a wood thrush at The New York Botanical Garden. My primary purpose was to get a decent-sized, reasonably sharp image. Unable to fill the frame with the thrush, even with a long telephoto lens, I composed quickly using the branch as a line to draw the viewer's eye into the scene. With my Nikon F2 and Nikkor 300mm telephoto lens, I exposed at f/4 for 1/125 sec. on Kodachrome 64.

T he idea that bird photographs can be thoughtfully composed strikes many newcomers to this endeavor as an exercise in wishful thinking. Is it really possible, while juggling all the technical and mechanical complexities of trying to produce a viable bird image, to take the time needed to compose? The very word "compose" seems antithetical to the activity and intensity novice bird photographers experience when they go into the field.

I wanted to portray these swans asleep on the shore of a lake near Vienna. When I noticed a small coot nearby, I thought that including it would make the image stronger because of its contrasting elements. The coot was smaller and darker than the swans, as well as off to the side. With my Nikon F2 and Nikkor 300mm telephoto lens, I exposed at f/8 for 1/30 sec. on Kodachrome 64.

Try both vertical and horizontal formats when you photograph birds. To successfully record snow geese in flight over New Jersey's Brigantine Wildlife Refuge, I opted for a vertical format. I liked the arrangement of the birds in the frame. I used my Olympus OM-4T and Zuiko 300mm lens, exposing at f/5.6 for 1/500 sec. on Ektachrome 64 Professional EPX film.

Of course, composing isn't your first order of business. But this doesn't mean that you can forget or ignore it. Even as you rush to catch a particular shot, you should think about taking it again if you have the chance. Don't get so caught up in celebrating the success of your first effort that you don't try again.

When you shoot extra pictures, you are likely to get the truly exciting photograph that you wanted in the first place. The reason is that this time—and it may take a few shots to achieve this—you've made the attempt to compose carefully. Furthermore, as you become more adept at and confident in your technique, you should place additional demands on yourself even with those first shots. Successful composition does require some reflection, but with continued effort it can become second nature to you.

If you absorb and practice the ideas in this chapter, your decisions will be more appealing right from the start. You'll frame your shots deliberately, look for and arrange the lines and shapes into a pleasing balance, bring out colors and textures, and generally make every inch of your photograph count. This is what good composition is about, and the better you become at composing, the more you'll do justice to the birds in your images.

FORMAT AND FRAMING

At its most basic level, composing means deciding on the format of your images. Should the picture be horizontal or vertical? All too often, photographers don't make this decision consciously. Since people tend to view the world along a horizontal plane and the 35mm SLR is built along horizontal lines, the vertical format gets short shrift.

This is unfortunate because many individual birds are taller than they are wide, so their natural shape suits a vertical format. Also, a group of birds sometimes forms a configuration that works better vertically. The

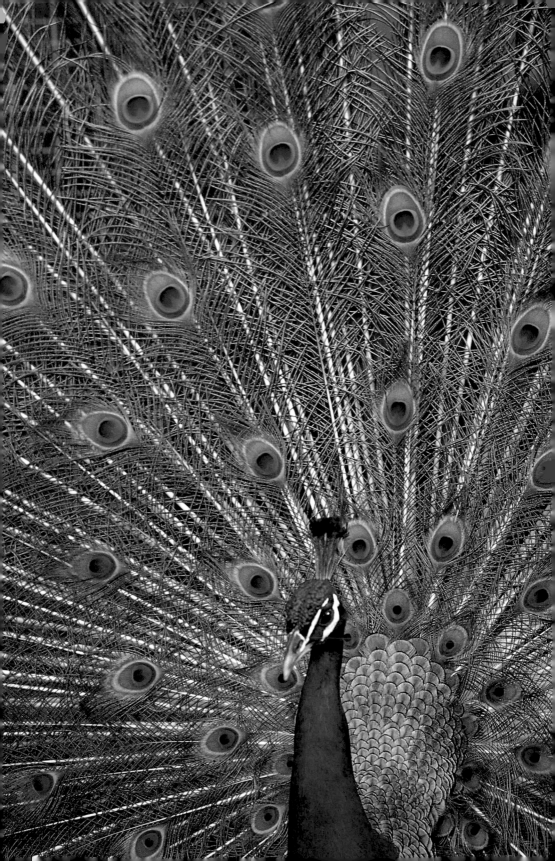

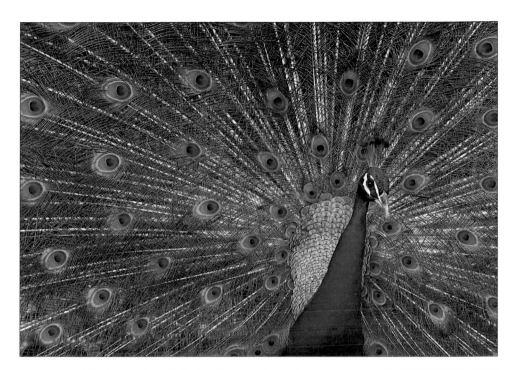

point is to think about and carefully decide which format is more appropriate for each subject. You may still opt for a horizontal format in many instances, but you should at least consider the alternative and, if you have the time, try it out. In fact, you should photograph subjects both ways as you develop your skills and compare the results. You may be surprised by which format you prefer for each image.

And remember, whenever you aim your camera you're deciding what stays in the frame. So it is essential to take a moment to make sure that you've included only what you really want in an image and eliminated anything that detracts from it. To help you evaluate the most suitable format and framing, you need to think about what you want to show and what is possible. Is your goal a shot of a single bird, a small group of birds, or an entire flock? How much of the environment do you want to include: a small slice or a broad panorama of the surroundings? Can you get close enough to the bird so that it fills the frame? If you can't, do you want the surroundings sharp or thrown out of focus?

Next, consider the placement of your main subject. For the most part, you should avoid putting the bird in the middle of the frame. Although exceptions exist, the Rule of Thirds is a good guideline to follow. Here, you place the bird to the left or right of center in a horizontal format, and toward the bottom rather than at the top in a vertical format.

If you're photographing a large flock of birds, mass them roughly in the same way—not in the center of the image, but somewhere along the lines that divide the frame into thirds. In addition, you should consider how the birds and various elements in their habitat constitute lines and shapes that you can arrange into a balanced configuration within the frame.

LINES AND SHAPES
No matter what kind of bird you're photographing, your image will be stronger and more dynamic if it works as an design of lines and shapes.

This peacock in Barbados was a most cooperative model. As it strutted around, I was able to take quite a few shots at a short distance to completely fill the frame with the most colorful and graphic parts of the bird. Such tight framing delivers a strong visual punch, so take advantage of this approach whenever you can by getting in close to your subject. I made the vertical shot with my Olympus OM-4T and Zuiko 90mm telephoto lens, exposing for 1/30 sec. at f/8 on Fujichrome 100 RD film (left). Continuing to keep the peacock tightly framed, I tried a horizontal format next (above). The effect is quite different, although both work visually. Using the same camera, lens, and film, I exposed at f/11 for 1/60 sec.

The flow that these abstract elements generate draws the viewer's eye into the frame and guides it along the picture's surface.

This may be the least spontaneous aspect of composition for those interested in photographing birds or other forms of wildlife. Photographers tend to gravitate so strongly toward their main subject that they downplay the value of these visual dimensions. But neglecting such elements adversely affects their results. The following suggestions will help you discover lines and shapes.

Lines in Birds. When people look at individual birds, they tend to see them as shapes rather than as lines. A few exceptions do exist, though. Envision the radiating lines in a peacock's open tail feathers. If birds can represent lines at all, they do so primarily as a group; think of a line of sandpipers scurrying along a beach or a line of sparrows sitting on a telephone wire. While the individual features of these birds may be indistinct, the picture of them may capture a worthwhile and typical scene.

You should also consider the lines you imagine as your eyes move from one bird to another. This variation on the childhood game of "Connect the Dots" works in bird photography as well. Notice if a particular line seems smooth and pleasing. If it doesn't, shift your shooting position a bit or wait until the birds have moved into a better configuration.

Lines in the Environment. Most often, the lines you must look to are those in the environment. They may appear as the twigs or branches of a tree, as the leaves or grasses surrounding a bird, as the waves of the ocean, or as the concentric ripples on a lake. Such lines provide information about the bird's habitat and add texture and graphic interest to the image.

Another interesting, highly graphic way to combine birds with their settings is to portray strata in the habitat as horizontal bands in your pictures. For example, follow a band of water with a band of land, then a

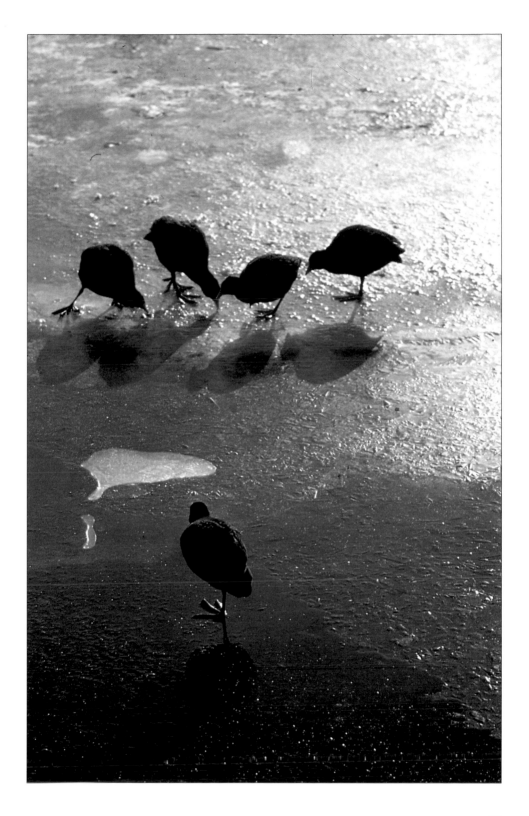

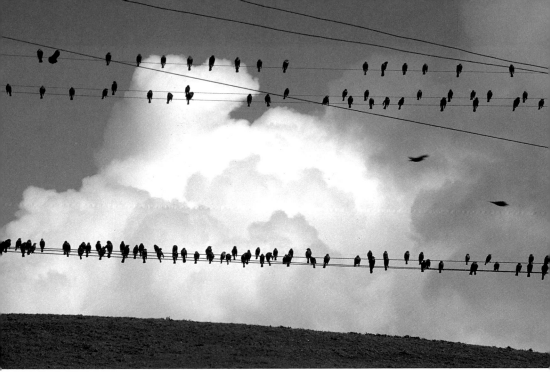

band of birds, and then a band of vegetation. Telescoped and foreshortened with a powerful telephoto lens, these horizontal bands look like flat layers on the film plane, each adding another color and texture to the overall image.

Shapes of Individual Birds. Of course, the most vital shape in an image should be that of a particular bird. For this shape to dominate the frame, it must be clearly delineated. This means that the bird must be facing in a direction that reveals its most telling or flattering shape. And in order for this shape to be readily discernible, it must contrast in some way with its surroundings. A bird will stand out if its color, brightness, or sharpness differs from that of its setting.

For example, if a backdrop is much brighter than the bird, use backlighting to produce a halo effect that outlines the bird and creates a silhouette. If, on the other hand, the backdrop is dark, use frontlighting to spotlight the bird. And if the color and light in a scene are uniform, simplify the backdrop by throwing it out of focus.

Repeated Shapes. Your images will go a measure beyond documentation if you incorporate a pattern of repeated shapes. These can be as simple as several birds of the same species, either facing in the same direction or in some compelling arrangement. Think of geese in flight, all going the same way; several coots on a shoreline, digging for a snack; a group of swans, huddling to sleep; or a whole flock of ducks, swimming in a lake. The more the shapes echo or mirror one another, the stronger the composition potential.

A good way to portray such repeating patterns is to look for and take advantage of reflections. These are clear signs of nature's symmetry. Be sure to bracket reflection shots toward overexposure, up to one stop, to compensate for the light meter's tendency to underexpose for the brightness of the water.

COLOR

Color adds a startling visual dimension to any composition. In terms of bird photography, however, color is both a boon and a bother. While many people associate birds with brilliant plumage, the truth is that color isn't a striking feature of most birds. And even when a birds is brightly colored, it is often so small and well camouflaged that its colors aren't the dominant element in the photograph.

Does this mean that you don't need to consider color when composing bird photographs? If color weren't important, most bird photographers would work in black and white—which isn't the case. While the most desirable source of color in bird photographs may be the color of the bird, you can find more reliable sources in the surroundings. To enrich your bird photographs via color, try the following techniques.

Enhance the Bird's Color. The best way to bring out the colors of birds and have them gleam is to make the most of the natural light. In the uniform illumination of overcast days or in deeply shaded areas, you'll have an easy time capturing, and exposing for, pastel tonalities and the cool palette of blues and greens. The low-angled light of both sunrise and sunset is particularly flattering for pink, red, and yellow birds. And if you're photographing birds that aren't colorful in their own right, such as a white egret or a buff-colored dove, you can opt to create a monochromatic palette in your image or to incorporate color from the environment (see below).

Use the Color of the Surroundings. You'll often find birds in settings that offer effective color contrasts. For example, set your bird subjects against the deep blues or greens of a lake, the pale turquoise of the ocean, or the brilliant reds of sunset light reflected in a wetlands. The intense blue of the sky can be a colorful foil to a bird of undistinguished color.

Don't be concerned if the sky isn't sunny and bright on a day you plan to photograph birds as long as you can stay dry. Some lovely monochromatic effects are possible in inclement weather. I photographed this American egret on a particularly dull day in Florida's Everglades National Park; however, the wide-open terrain remained bright enough so that I was able to make this action shot. The soft light on both the bird and the water produced the color effect I wanted, and a fast shutter speed enabled me to freeze the egret just as it was poised to lift off. Shooting Fujichrome 100 RD film with my Olympus OM-4T and Zuiko 350mm telephoto lens, I exposed at f/2.8 for 1/500 sec.

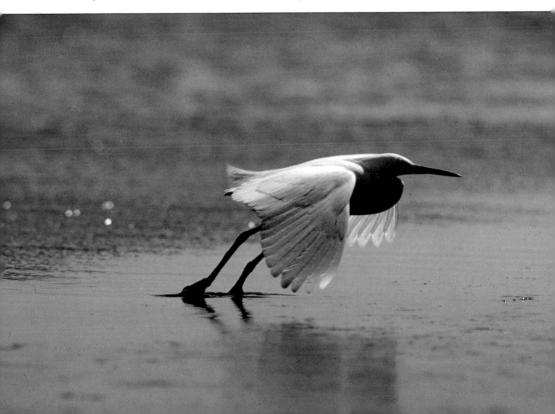

When I saw this small cactus wren on the branches of a creosote shrub at the Arizona-Sonoran Desert Museum, I wanted to photograph the bird within its colorful surroundings. But I realized that its speckled feathers could easily get lost among the bright flowers. Because I was 12 feet from the bird, I set my Zuiko 50-250mm zoom lens at 250mm, selected an aperture of f/5.6, and then focused on the bird's eye to let the bird stand out against a wash of yellow. With my Olympus OM-4T, I exposed Fuji-chrome 100 RD film for 1/250 sec.

I photographed the distinctive red epaulets of this red-winged blackbird as it rested on its perch and sang. I threw the uninteresting backdrop out of focus to increase the color contrast and to eliminate background distractions. With my Olympus OM-4T and Zuiko 50-250mm zoom lens, I exposed for 1/500 sec. at f/4 on Kodachrome 64.

Tropical birds can be quite colorful. Unfortunately, getting close to them isn't always possible. This vivid kingfisher in West Africa kept darting back and forth between the nearby waters and this tree. Once I knew where the bird was likely to land, I prepared to shoot from an angle that would place the bird against the gray of the tree. My patience paid off. Working with my Nikon F2 and Nikkor 200mm lens from a shooting distance of 40 feet, I exposed at f/4 for 1/60 sec. on Kodachrome 64.

This tiny warbler on the island of Bonaire was a discovery in itself, but the shrub with needle-like leaves spiced up the scene. To get everything tack sharp, I mounted my Olympus OM-4T and Zuiko 350mm telephoto lens fitted with a 1.4X tele-extender on a tripod. I then focused on the bird's eye and beak. The exposure on Elta chrome 100 Lumière Professional LPP film was f/8 for 1/250 sec.

I noticed this flicker repeatedly returning to this tree in New York City's Central Park. I kept inching closer with my Nikkor 300mm telephoto lens, hoping to reveal the intricate texture of the flicker's feathers. Luckily, the bird came in for a landing at just the right moment. I used my Nikon F2 and exposed Kodachrome 64 at f/5.6 for 1/125 sec.

Even snow can provide contrast to such birds as nuthatches, whose subtle colors would be lost against a bright backdrop.

The most reliable source of color comes from the vegetation that often surrounds birds in the wild. As the seasons unfold, these colors can go from a sharp green in spring to a deep green in summer, turning to yellow, orange, and red in the early autumn, and then to a tawny gold in late autumn. Whatever the time of year or the situation, you should find a perspective that sets the bird against a contrasting backdrop.

Create a Wash of Background Color. If you can't find the exact scene that you would like to shoot, use your imagination and technical knowledge to create it. Remember, you don't just take a photograph, you make it. So, if your bird subject isn't an interesting color and the background color is only a slight improvement, try throwing the backdrop out of focus. Whatever snippets of color exist there will spread across the frame, filling the space around the bird with a soft wash of color. To produce this effect, limit depth of field by using a longer telephoto lens and a wide-open aperture setting. This is also a good way to handle a busy backdrop, as well as one with dappled, irregular light. Another option is to "sandwich" your colorless image with another one that is rich in color (see Chapter 6).

TEXTURE

The camera's ability to record texture adds immeasurably to the sense of reality in bird photographs. Ideally, the texture of the bird should be so palpable that viewers can almost feel the bird. This tactile quality can also extend to the bird's surroundings, so that bark, leaves, thorns, and needles seem to pop out of the picture. Of course, the key to such vivid texture is a tack-sharp image. You can achieve maximum sharpness several ways.

Minimize Movement. Even the smallest subject movement is magnified when you're shooting with telephoto lenses. When you work with these heavy, bulky lenses, keep your camera on a sturdy, stable tripod that eliminates vibrations or unsteadiness. Once you are as still as possible, exercise patience until your subject is as still as can be. In some cases, this means watching and waiting until a bird maintains a position, even if only for a split second. You can also take several shots in rapid succession while a bird is relatively immobile. In other instances, you'll have to observe a bird's habits and anticipate its moves, so that you can catch it at a moment of reasonable stillness.

Maximize Depth of Field. While you continue to need a fast shutter speed to stop movement, you should use the smallest aperture you can in order to keep textures as sharp as possible. If you want to throw the background out of focus, use a long lens or move closer to your subject. But you must maintain enough depth of field, so that the bird's feathers are in sharp relief.

Focus with Precision. Always focus on a bird's eye if it is visible in the image. If the eye isn't discernible, focus on another important feature, such as the bill. Although feathers are the most highly textured part of the bird, don't focus on these if this will cause the eye and beak to go out of focus. However, if you're waiting for a bird to land on a favorite perch, you may have to focus on the tree bark or foliage near that spot in order to record a fairly sharp image the instant the bird lands. You can then fine-tune the image if the bird stays in place.

FILLING THE FRAME

The final step of the composition process takes place just before you press the shutter release. This is when you should take a last close look at the entire frame. Go down a mental checklist to make sure that what you see in the viewfinder matches your intentions in every way possible.

Fill the frame completely with visual material that contributes to the image you have in mind. When you photograph groups of birds, think in terms of a star player and supporting actors. Let the configuration of lines and bands or repeating shapes and patterns occupy the major portion of

What intrigued me most about this griffin vulture in Austria were the soft, fluffy feathers of its crown and collar. To capture their texture, I had to increase sharpness in the foreground and reduce it in the background. The contrast between the pale feathers and the brown in the distance helped separate the bird from its backdrop. To achieve the exact effect I wanted, I moved within 8 feet of the bird and used my Nikkor 35mm wide-angle lens. This increased depth of field in the foreground, where I wanted it for sharpness, but it didn't alter the background, which stayed out of focus. Shooting with my Nikon F2, I exposed Kodachrome 64 for 1/30 sec. at f/5.6.

One way to fill the negative space in the frame is to include the sky. Just make sure that it has color interest and is relatively cloudless. This is the approach I followed for this photograph of a loggerhead shrike in Florida. I took a spot-meter reading of the bird and then shot at the indicated exposure in order to keep the bird reasonably white against the crystal blue sky. I used the wire as a diagonal line to make the shot dynamic and then waited for the bird to face me. I didn't polarize the scene because I was using a fast shutter speed and medium-speed film. Shooting with my Olympus OM-4T and Zuiko 350mm telephoto lens fitted with a 1.4X tele-extender, I exposed Fujichrome 100 RD film at f/2.8 for 1/500 sec.

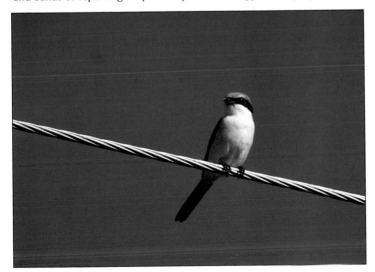

Composing with purpose means filling the frame with visually relevant material. Aware that I couldn't fill the frame with the bird alone, I worked on a composition that would show the bird in the context of the wetland grasses in Papua New Guinea. I placed my subject slightly to the left of center in the positive space, and then loaded the rest of the frame, the negative space, with the colorful and highly textural vegetation. Working with my Olympus OM-4T and Zuiko 300mm telephoto lens, I exposed at f/4 for 1/250 sec. on Kodachrome 64.

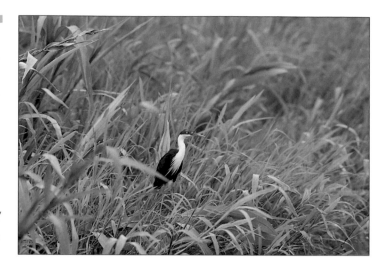

For this shot of a single white ibis, I doubled its size within the frame by including its mirror image in the waters of Florida. After homing in on the bird with my Zuiko 350mm telephoto lens, I played up the light contrast by taking a meter reading of the bird and underexposing by a full stop. This saturated the beak's orange color and darkened the backdrop and waters. the result: a dramatic portrait. Shooting with my Olympus OM-4T, I exposed for 1/125 sec. at f/2.8 on Fujichrome 100 RD film.

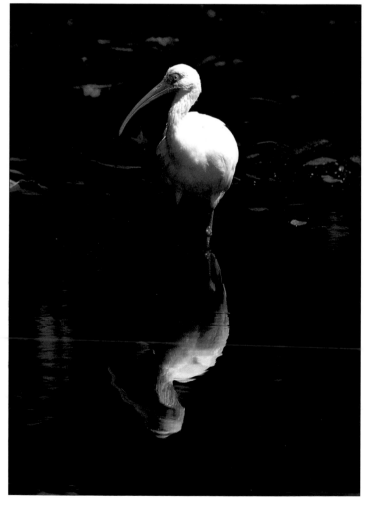

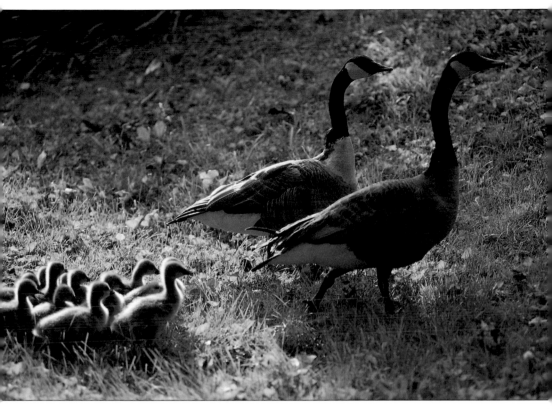

the frame. If your subject is a single bird, get close enough to it, so that it fills a major portion of the frame.

Alternatively, you can incorporate the surroundings to help fill the frame in a meaningful way. Use vegetation, water, or the sky as negative space. This is the part of an image that sets off the main subject without dominating it. Such background areas of negative space have a shape of their own, whether they are simple and flat, sharp and highly textured, or out of focus.

Next, check the contours and corners of the frame, looking for intrusive elements. These include spots of bright light or nearby blades of grass that can spoil an otherwise carefully designed composition. If you see anything extraneous or distracting in the image, eliminate it by changing your perspective slightly, rethinking depth of field, or waiting a moment until the distraction moves out of the frame. And while electronic imaging allows you to remove photographic flaws, you should always try to shoot a scene perfectly the first time.

When one bird can't fill the frame, you'll find that several birds may be able to. I composed this picture of a family of Canada geese in Kentucky in such a way that they extended end to end across the frame. In fact, I cut off the chicks to create the impression that there were even more in the scene. With my Olympus OM-4T and Zuiko 50–250mm zoom lens, I exposed for 1/250 sec. at f/5.6 on Ektachrome 100 Lumière Professional LPP film.

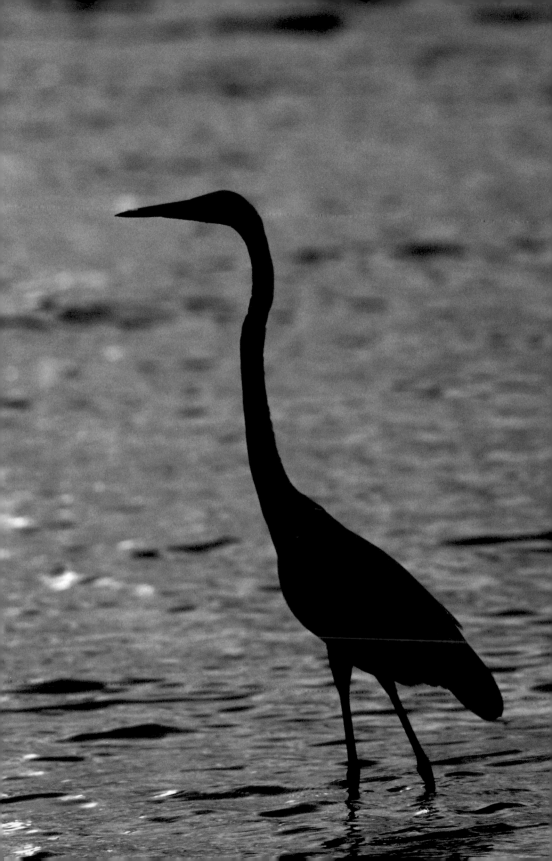

CHAPTER 5

Exploring Natural Habitats

Every natural habitat offers bird photographers opportunities and difficulties. In Florida I know that I'll see American egret, but I also know that the environment will be bright. In this picture I opted to shoot a silhouette of the egret, both to reveal its distinctive shape and to make good use of the highly reflective water. With my Olympus OM-4T and Zuiko 350mm telephoto lens, I exposed at f/2.8 for 1/125 sec. on Fujichrome 100 RD film.

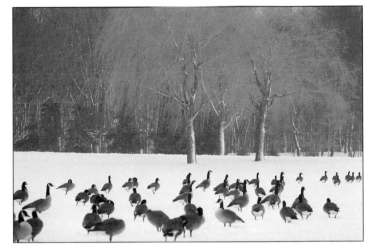

You can find birds near home wherever you live, all year round. This flock of Canada geese took up residence at the PepsiCo Sculpture Garden in Westchester County, New York. For this winter shot, I wanted to combine the birds with the park-like corporate garden. Using my Nikkor 300mm telephoto lens, I composed the image in such a way that the birds dot the snowy lower portion of the frame, and the delicate fronds of the weeping willows sweep across the upper part. Working with my Nikon F2, I exposed Kodachrome 64 for 1/125 sec. at f/5.6.

Whatever your interest in and involvements with nature photography may have been, they'll take a great leap forward once you begin to photograph birds. Not only will you have to apply the technical and aesthetic skills you've acquired, but you'll have to do so under much more demanding conditions than you probably faced when shooting other nature subjects. Start by working in locations and under conditions that are likely to be productive and relatively easy. You can then build your repertoire gradually until you are ready for the most challenging situations.

The purpose of this chapter is to help you understand the photographic benefits and pitfalls of each habitat. Begin by exploring the most accessible environments: those in which birds are relatively large, reasonably immobile, or otherwise easy to spot. Consider such locations as your own backyard, local nature centers and zoos, and neighborhood parks and gardens. When your skills improve, you can move on to wilder locations. Seek out nesting and breeding grounds, where birds congregate in large numbers and are likely to return to the same spot repeatedly. You may also want to visit feeding spots that attract many birds. Coastlines, beaches, and wetlands—bogs, marshes, and swamps—are located near many residential areas.

Such natural enclaves are prime locations for practicing action shots. With birds at hand in high numbers, you can concentrate on your photography rather than on finding or chasing your subjects. Try showing birds as they groom and preen, take off and land, fly overhead, and stalk their prey. Once you hone these skills, you can explore the most challenging environments for bird photography: fields, meadows, deserts, and, the most difficult of all, woodlands.

As you shoot in each habitat, keep a specific goal in mind. For example, begin by attempting to fill a significant portion of the frame with the bird. Once you achieve that goal with some consistency, move on to the goal of recording the bird's eye in sharp focus and, if possible, with a gleam or sparkle. Next, you can work on capturing a bird's movements.

CLOSE TO HOME

Unless you live in the heart of an urban district, chances are that you'll find or be able to attract birds right to your home turf. Getting birds to come to you gives you a wonderful chance to observe and learn about their habits, typical movements, and favorite perches, as well as to observe their charm and study their features at fairly close range.

Birds will visit your backyard year round, whether they live in the area or they're just passing through during a migratory period. More birds will venture close if you provide food or water. Check with a local naturalist for the kinds of food that will attract the birds in your area, particularly those that come only in the winter. Setting up feeders and baths and planting bushes with berries and/or seeds that birds like to eat practically guarantee that birds will come by and appear in the open. Try to notice their favorite perches, hiding places, and possible nesting spots near feeders and baths, so that you'll know where to look for them when you want to shoot.

Depending on where you live, you may attract a wide variety of birds. Among the small birds, sparrows are ubiquitous; cardinals, nuthatches, and chickadees gravitate toward shrubs and wooded spots; and hummingbirds love red flowers. Among the medium-size birds, look for mockingbirds along fences; robins and starlings on lawns; and doves, blue jays, flickers, and woodpeckers in wooded areas.

Because you'll be able to get reasonably close to your subjects, you won't need the longest lenses on the market in order to start practicing your bird photography. From a distance of 10 to 20 feet, a 200mm to 400mm telephoto lens fitted with a 1.4X tele-extender will fill the frame with a robin-sized bird reasonably well. Since lenses' minimum focusing distances vary, you should check to see how close you can focus with your lens. Next, mount your camera on a tripod, move into position, preset your focus and exposure, and wait for the birds to arrive.

If you're working from inside your house, you can shoot through a window, using the house as an effective blind. Strategically place the bird

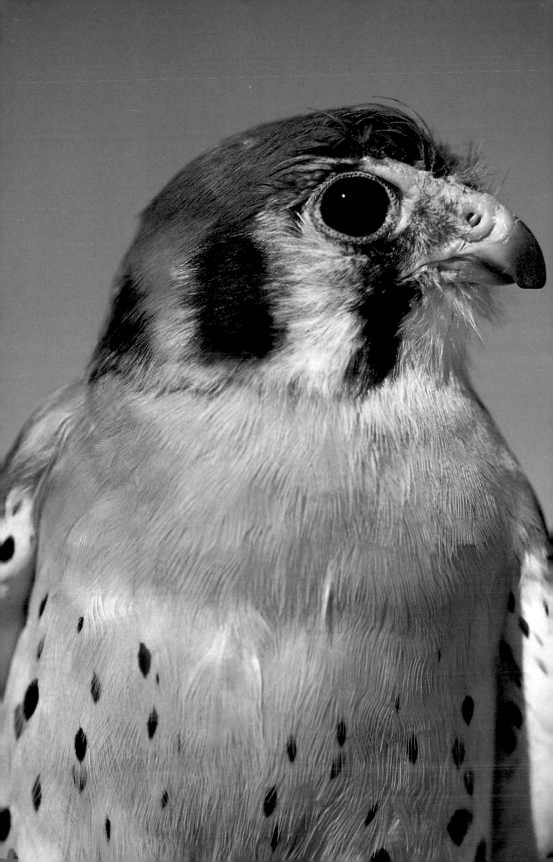

feeders and baths near windows. To get closer to bushes or trees where birds like to perch, use your car or a backyard tent as a blind. If you find yourself shooting with the window closed during the winter months, place your lens within an inch or two of a clean window, but not against the glass. Use an extension tube if you need to focus closer.

But even at relatively short distances, you shouldn't expect to get full-size portraits of small birds. Try instead for pictures that show a portion of the setting. If, however, the background is jumbled or distracting, simply throw it out of focus.

As you gain confidence, start honing your skills in preparation for shooting action. Remember, birds are most active during the early-morning and late-afternoon hours. Pay attention to how the birds flit from spot to spot before coming down to a bath or feeder. In time you'll learn to anticipate their movements, thereby enabling you to capture decisive moments when they land, begin to fly, feed, wash, and preen. To freeze these split-second motions, you can try adding light with your electronic

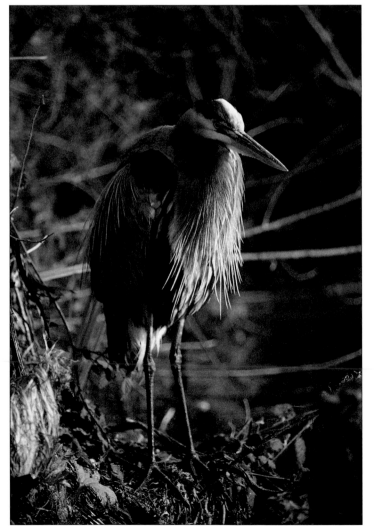

Wetlands are home to many birds, such as this great blue heron, which I photographed in Florida's Everglades National Park. Herons are relatively easy birds to photograph because they are large and tend not to move in erratic ways. Here, I wanted to highlight the bird's delicate chest feathers, so took a spot-meter reading of the gray part of the heron and shot at the suggested exposure. With my Olympus OM-4T and my Zuiko 350mm telephoto lens fitted with a 1.4X tele-extender, I exposed at f/2.8 for 1/250 sec. on Kodachrome 64.

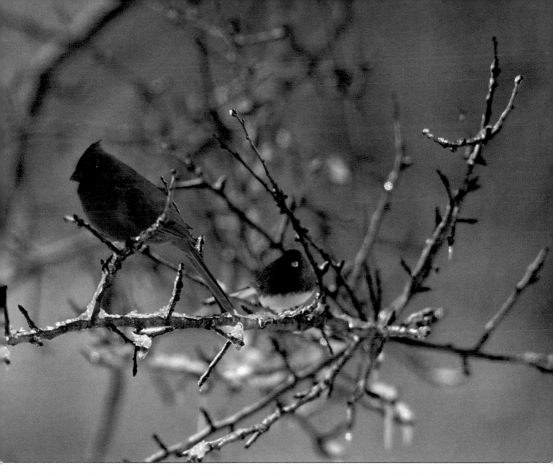

flash unit—if you can get within 15 feet of your subject. Once you mount the flash unit on your camera, you're ready to shoot.

Your flash unit comes in handy in other situations, too. It provides fill-in light for shots taken at or after sunset, freezes motion in daylight, and eliminates bothersome shadows. An electronic flash unit also increases image sharpness by letting you work with a small aperture.

Not far from home, you can find many kinds of birds, including large birds, at aviaries and nature centers. You can get close enough to your subjects to be able to shoot full portraits, as well as try for some closeups using telephoto lenses that range from 200mm to 400mm in focal length. As you explore an aviary or nature center and find a promising location, determine how close you can get to the bird you want to photograph, and then stay put while you shoot. Birds are creatures of habit and will return to their favorite perches, so you'll have more success if you don't move around too much and remain unobtrusive.

If you need to shoot into a cage, obscure the wire by placing your lens right up against the mesh and then set the aperture to its widest setting. Because you'll need to mount your camera on a tripod, you should check in advance to see if you need special permission from the aviary in order to use a tripod. If the aviary won't allow such a setup and you must handhold your camera, use fast film and your lightest, least cumbersome lens. An alternative is to go to naturalist demonstrations, during which handlers take large raptors out of their cages and bring them close to spectators. In this situation, you'll get a chance to use short lenses, which

While photographing this duo in a friend's yard, I decided to try for a more naturalistic setting than the feeder itself. The junko was less active than the cardinal, so I watched the cardinal until I was familiar with its pattern of stops. Then I set my camera on a tripod and focused on a spot where I noticed the cardinal had perched. Luckily, a junko had stopped for a rest in the same tangle of branches. In time, the cardinal returned, and I got my shot. Here, I used my Olympus OM-4T and my Zuiko 350mm telephoto lens fitted with a 1.4X tele-extender. The exposure was f/2.8 for 1/250 sec. on Ektachrome 100 Lumière LPP film.

can result in good portraits. A 100mm macro lens is ideal for focusing very close at such demos.

As you photograph in these settings, be alert to background distractions, such as wire mesh, signs, people, or bright spots. You can obscure these unwanted elements in several ways. These include finding a better perspective, blurring the distractions by limiting depth of field via a wide-open aperture, and using your flash unit to increase contrast and darken the backdrop. If you are no more than 15 feet from your subject, the flash may also help to illuminate birds that are in the shadows or to freeze their movements.

PARKS, GARDENS, AND ZOOS

These recreational areas are home to many local wild birds, as well as numerous migratory species that pass through in season. Among the smaller birds you are likely to encounter in gardens, parks, and zoos are tiny nuthatches and chickadees; small woodland species, such as woodpeckers, flickers, and doves; thrushes and mockingbirds on open lawns or short trees; and relatively tame species of large birds, such as ducks, swans, geese, gulls, ibises, egrets, and herons, along lakes and ponds.

If you think that the surroundings strengthen your image, this is a good time to photograph birds in their environment. Alternatively, if you can get close enough to your subjects, include your family members or friends in your bird shots by using standard or wide-angle lenses. In parks and gardens, you may be able to get fairly close to some reasonably large birds, such as swans and ducks. If this happens, use your longest lenses to get portraits that fill the frame.

Another option when working in parks, zoos, and gardens is to record the birds' activities. For quick bird movements, use a fast shutter speed. For long, smooth movements, such as birds flying over water, try panning the subject. A fast shutter speed, of at least 1/125 sec., stops such

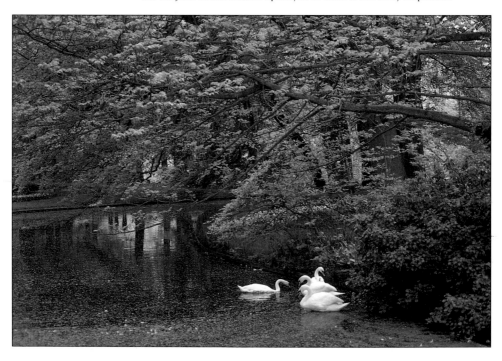

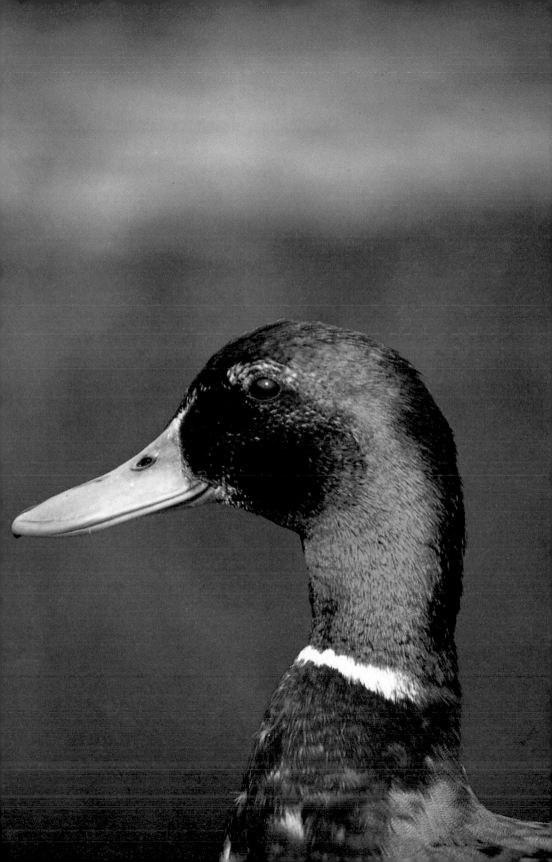

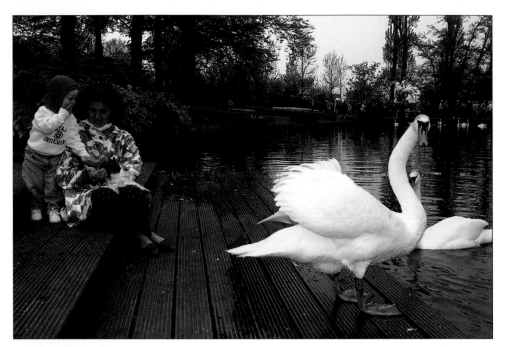

Swans and ducks often come out of the water, so that park visitors can feed them. For this shot, I wanted to show the child feeding the swan. By the time I got into my shooting position, the scene had changed. But by using my Zuiko 35-70mm zoom lens, I was able to quickly compose this photograph, which shows the child's excitement and the swan's self-satisfaction. With my Olympus OM-4T, I exposed at f/5.6 for 1/60 sec. on Fujichrome 100 RD film.

motions as feeding and grooming, but an even faster shutter speed of at least 1/250 sec. is required for freezing takeoffs and landings.

Be sure to pay attention to the background before you press the shutter-release button. You may notice such distractions as people, buildings, signs, lampposts, and trash baskets in parks, gardens, and zoos that can mar an otherwise fine image. You can correct this problem in two ways. One solution is to change your perspective in order to better camouflage the background; move lower, higher, or to the side. The other choice is to limit depth of field to render the backdrop out of focus.

WETLANDS

Wetlands are the prime, year-round feeding and breeding habitats for countless resident and migratory birds. Birds flock by the thousands to wetlands all over the world. Here, you'll find large wading birds, such as egrets, herons, cranes, ibises, and spoonbills; high numbers of waterfowl, ducks, and geese; many birds that dive for fish, such as cormorants, pelicans, loons, grebes, kingfishers, and terns; and birds of prey, such as ospreys and hawks.

Wetlands are important way stations along birds' migratory paths because they are rich in food resources and provide sanctuary for vulnerable young. But as vast and full of birds as wetlands are, the species they attract tend to be shy, private, and skittish. Therefore, you probably won't be able to get very close to the birds, except in those places where human visitors have become commonplace, such as Florida's Everglades.

Don't expect to get closeup images of the birds unless you are particularly lucky or persistent. You'll have a better chance trying to capture images that show the birds within the context of their immediate environment. Again, to avoid becoming frustrated, start with the most feasible shots and gradually increase the level of difficulty.

Because wetlands are beautiful habitats, you should begin by working on images that show birds in their natural settings. Be sure to frame and

compose carefully; such images depend more on lines, shapes, and colors than closeup shots do. Balance the elements of land, water, grasses, and sky, but be let the bird remain the visual focal point of the image. With your long lenses, telescope and compress the spaces between various strata of the environment, so that they appear as horizontal bands juxtaposed against one another.

Wetlands are good locations to try out new ways of framing birds aesthetically within their surroundings. For example, experiment by using foliage either as foreground material or as a backdrop for a bird. Another possibility is to shoot through vegetation, blurring the foreground by getting within a few inches of the grasses and using a wide-open aperture setting. However, make sure that you meter the bird, not the more reflective foliage, to get optimal exposure.

The warm tones visible in early-morning and late-afternoon sunlight are particularly vibrant in wetlands. Take advantage of the way this low-angled illumination brings out the textures of the natural vegetation and highlights the shapes of the birds. At and after sunset when the water is awash with the brilliant colors of the sky, shoot silhouettes. On overcast days, establish a subtle mood by working with soft greens and browns or creating a monochromatic effect. At midday record the strong illumination on wading birds or ducks on the open water. This is also the time to make the most of apparent contrasts by, for example, setting a brightly lit bird against a shadowy backdrop.

Since wetlands are bright, open areas, be especially careful to avoid glare or flare from highly reflective bodies of water. If you see lots of white spots or streaks in the water, reposition yourself to get a better perspective. (A polarizer can reduce such glare, but it also cuts the speed of the lens by 1½ to 2 f-stops; this, in turn, may preclude using a fast shutter speed to stop motion.) Of course, you should avoid metering the brightest areas. Instead, home in on your bird subject with a spot meter. If you

The wide-open spaces of a wetlands make it possible to glimpse and photograph large birds in action. In one of Florida's many wetlands, I captured this American egret taking off. In order to get this shot from a distance of 30 feet, I took advantage of my Zuiko 350mm telephoto lens and my Olympus OM-4T's motorwinder, panning through a series of fast exposures. I used the automatic-exposure setting on the camera to ensure getting a proper exposure while the bird was moving. The exposure was f/2.8 for 1/250 sec. on Fujichrome 100 RD film.

Herons are basically shy birds that usually hide among the grasses and other wetlands vegetation. So when I saw this great blue heron stalking fish out in the open in a Florida wetlands, I wanted to spotlight the bird against its immediate environment. I liked the warm illumination bathing the entire scene and wanted to include the heron's reflection in the water. I then took a spot-meter reading of the heron's back and shot at the suggested exposure, knowing that the fast shutter speed would freeze any movement. Shooting with my Nikon F2 and Nikkor 300mm telephoto lens, I exposed Kodachrome 64 at f/5.6 for 1/250 sec.

must rely on a general meter reading, remember that it will tend to over-value the brightness and underexpose the bird. To counteract this, you should overexpose from a general meter reading by up to one f-stop when you shoot in wetlands.

When you are ready to move in for some more intimate shots, ask a naturalist where nests are located. In season, you are likely to find mother birds and their babies in these spots, which is an irresistible combination. But don't try to get too close to your subjects: some birds will attack anything that seems like a threat to their young. Worse yet, some birds may be scared off and not return to their nests, leaving their young unprotected and unfed. But chances are that you'll have to keep your distance even if you want to get close to nesting or feeding grounds. This is because wetlands birds often nest in remote rushes or up in the trees. They are also hard to sneak up on and quick to fly away.

You can get reasonably close to nesting birds in several ways. Take advantage of built-in blinds along boardwalks in protected areas. Keep in

mind, though, that if a lot of people are on these boardwalks, your camera may pick up vibrations. These may disturb your picture-taking even if your camera is mounted on a tripod.

On land, you can also try using your car as a blind. If you see birds along a waterway that is near a road or path, pull up slowly, stop, and stay in the car. Birds—and other forms of wildlife—often don't seem as threatened by a vehicle as by a human being. Shoot through your window, bracing your heavy lens on a beanbag draped over the window frame.

Still another option is to photograph on the water from a small, quiet boat, preferably a rowboat or canoe. If you use a motorboat, be sure to turn off the engine and float toward your destination quietly. Don't be surprised if the more nervous birds take off just as you approach.

If you are daring and there are no restrictions, you may prefer to wade into some of the shallows to get to where the birds are. If you do, wear high wading boots or rubberized overalls, and be prepared to wait a while until the birds get accustomed to your presence. Be sure to plant your tripod firmly in the ground below the shallow water.

Once you are close enough, take a few moments to watch the birds as they go through their routines. Use a "shoot first, then shoot again" technique rather than waiting for the perfect moment. When you notice an activity that interests you—stalking fish, feeding, grooming, landing, or taking off—follow the movement with your camera, but don't shoot yet. When you get a clear sense of the image you want, start shooting and then repeat a series of shots in order to capture a particular movement on film.

To help you anticipate a specific action before it occurs, practice saying "now" out loud, right before you expect a bird to make its move. Then check if the bird has acted according to your prediction.

Once you are adept at this technique, press the shutter-release button at the same instant you say "now." Keep following the movements of

Shooting from a distance of 150 feet, I opted for this panoramic portrayal of a heron, which emphasizes the setting. The tall, feathery grasses of the Dutch wetlands added color and textural interest to the image. And the late-afternoon light enriched the natural colors of the environment. I shot this downward perspective by standing on a nearby dike. Working with my Olympus OM-4T and Zuiko 50-250mm zoom lens, I exposed at f/8 for 1/60 sec. on Fujichrome 100 RD film.

Light has quite a dramatic effect on wetlands. The late-afternoon sun transformed the colors of this wetlands in New Jersey, bathing the snow geese in a strong spotlight. I was primarily interested in a composition that made this illumination particularly vibrant, so I took a meter reading of the grasses and underexposed by a full stop. Then to bring out the texture of the grasses, I selected a small aperture setting, even though it called for a slow shutter speed. With my Olympus OM-4T and Zuiko 350mm telephoto lens, I exposed at f/8 for 1/60 sec. on Fujichrome 100 RD film.

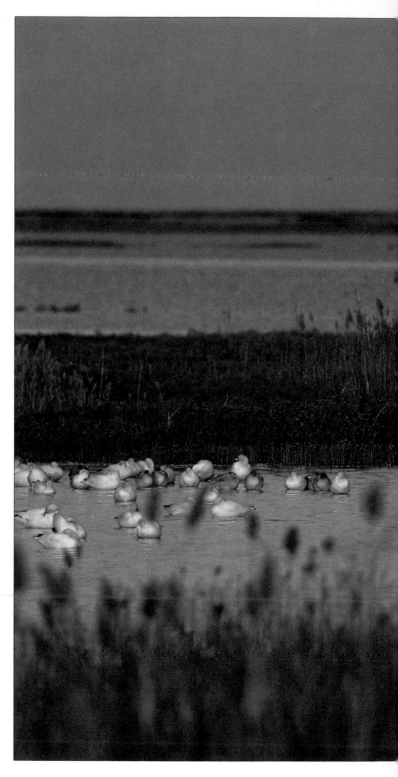

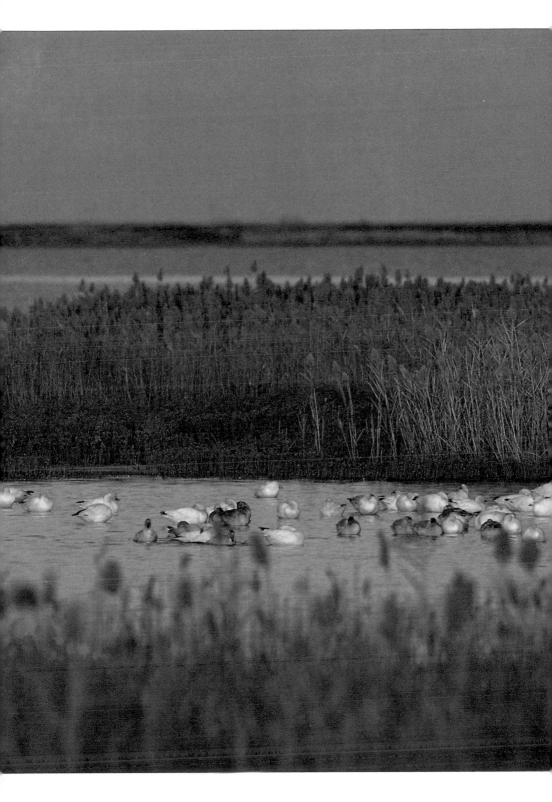

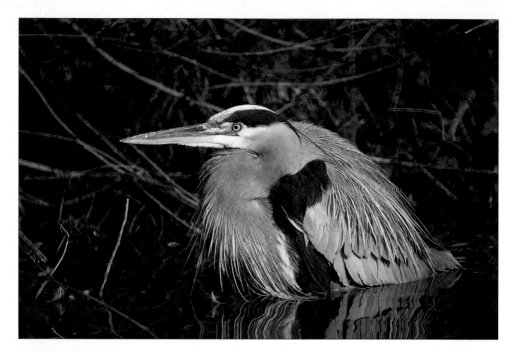

This great blue heron in a wetlands near San Francisco was crouched in its hunting posture. Because my subject was only 20 feet away, I fully extended my Zuiko 50-250mm zoom lens to frame fairly tightly. I overexposed by 1/3 stop to brighten the bird, which was in warm light. I used my Olympus OM-4T and exposed at f/5.6 for 1/60 sec. on Kodachrome 64.

This scarlet ibis on the island of Aruba was busy grooming. With the bird standing on a rock some 15 feet offshore, I turned to my Zuiko 50-250mm zoom lens to get a full image. I underexposed by 1/2 stop to saturate the bird's color and darken the surroundings to increase the contrast with the bird. Working with my Olympus OM-4T, I exposed for 1/125 sec. at f/8 on Fujichrome 100 RD film.

your subject, but this time taking a series of shots during the progress of a particular movement. In some ways landings are the easiest to follow because you can see the bird as it comes in. To record the action, pan as the bird approaches and then take several shots in quick succession using your camera's built-in motorwinder or motordrive. Landings happen quickly, so begin shooting while the bird is still in the air.

For other actions, such as a heron stalking a fish in the water, shoot the various constituent moves: as the bird hunches up, again as it stretches out and pauses, and again when it lunges forward. For shots of an egret taking off, watch for signals that it is about to fly and then begin shooting a moment before the actual takeoff starts. Continue shooting several more pictures as the takeoff progresses. Always use a fast shutter speed, at least 1/250 sec., to stop movement and maximize sharpness.

COASTLINES AND BEACHES

Coastlines and beaches are excellent environments for finding and photographing shorebirds. Here, you can find a wide variety of resident and migratory birds, often congregating in sizable flocks at or near the water's edge. These birds—which range from large gulls, cormorants, pelicans, and ibises, to midsize terns and skimmers, to small sandpipers, plovers, willets, and dowitchers—stay in open, unobstructed areas. This makes them easy to see.

This is just one reason why photographing birds along beaches and coastlines is relatively simple. Shorebirds tend to stay in an area for a while, giving you time to work on your photograph without having to rush unduly. And, for the most part, you'll be working with bright light, so you can use a fast shutter speed and even handhold your camera.

Shorebirds are also fairly tolerant of humans. The birds become so preoccupied with their own activities that they don't bother with people as long as spectators don't physically intrude on their territory. In the spring, many shorebirds build nests in the open, sometimes in grasses or

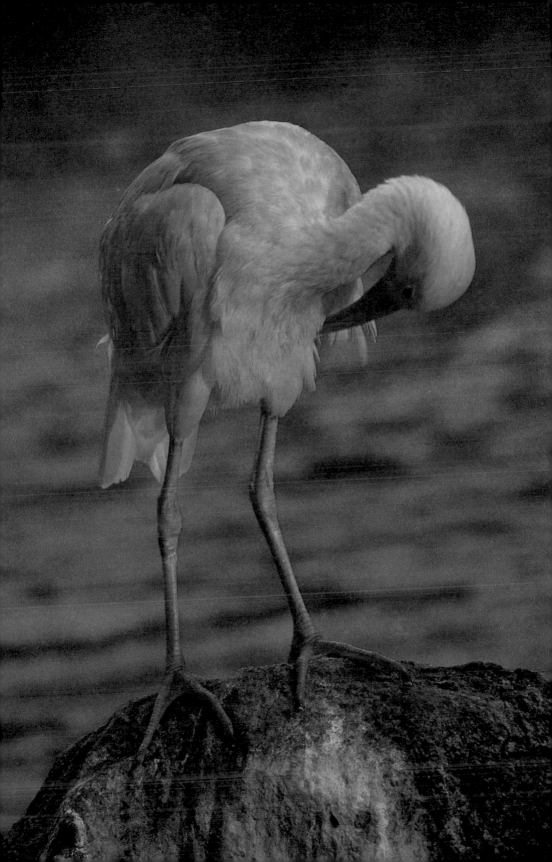

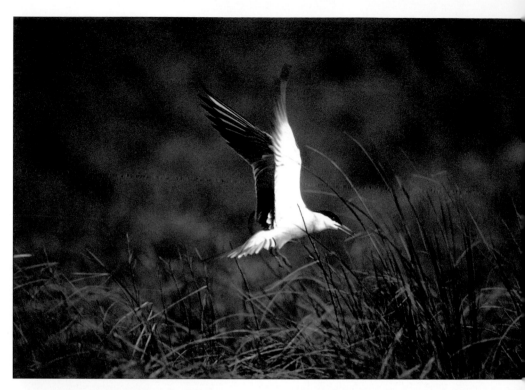

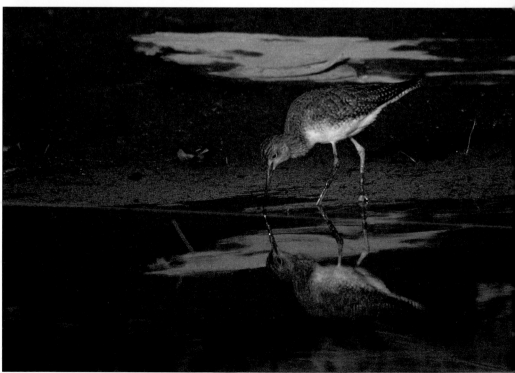

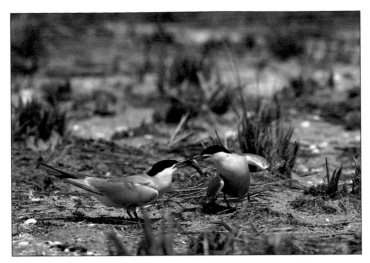

For this shot of a tern at Jones Beach in New York, I wanted to capture the bird in flight. But terns move fast, swooping, diving, and attacking. I had to work from a safe distance. Lying low on the sand, I watched for incoming terns. This one was in just the right location, and I quickly got off a series of shots, panning as the bird flew by. With my Nikon F2 and Nikkor 200mm lens, I exposed at f/4 for 1/250 sec. on Kodachrome 64.

the sand; this gives you a chance to observe their activities as they bring fish back to their breeding grounds.

When you photograph near coastlines and beaches, you have an opportunity to show birds from many different perspectives. Start with shots that incorporate views of the environment, using everything from bright sun to the delicate mists that give seaside photographs special character. And take advantage of low-angled morning or afternoon illumination to capture the gorgeous colors that suffuse the shore after sunset.

If the birds are in bright light, wait for them to face the sun or turn perpendicular to it. This frontlighting or sidelighting, respectively, will highlight the bird's shape and feathers. However, watch for bright backlight or reflected light off the water; you may have to go for a silhouette under these conditions. Try to find out or figure out in advance which way the sun will be facing in relation to the shoreline. This way, you can plan to be at your chosen location for the exact kind of illumination you want.

From a distance of 35 feet or more, you can portray birds in groups, scampering in front of the waves, lounging on seaside cliffs, digging in tidal pools, or resting on sandbars. Use a low perspective to include the water or beach areas with the birds. If your camera is mounted on a tripod, you may be able to take many of these shots and get them sharp.

For closer shots, you may prefer handholding your camera, so that you can maneuver to follow individual birds up in the air or pan them as they fly over the water or shore. Stake out a promising location, and work with a lens up to 300mm in focal length, using the following "step-stop-step" technique:

■ **Start by taking an establishing shot**, the kind that shows your subject in its setting.

■ **Then move forward a few steps and stop.** Take another shot, homing in on activities that interest you. Look for birds diving into the sea, swooping along the shore, grooming themselves, hovering above, fighting over a fish, and digging for snacks in tidal pools.

■ **Plan your next series of shots, and take them.** Then repeat the process, getting closer to your subject each time and discovering what you can see and record from that distance.

As you move in, however, watch the tide. Shorebirds move with the tide in order to follow their food supply. You can get relatively close to your subject, but don't lose track of where the water is going to be. If this

Dowitchers tend to be skittish, so I didn't want to alarm this one, which I found on a New York beach, by getting too close. I took advantage of the bird's complete concentration on digging for food to set up a shot showing it engaged in this typical activity. I used my Olympus OM-4T, my Zuiko 350mm telephoto lens fitted with a 2X tele-extender, and a tripod to compensate for the distance. The dramatic sunset illuminated the bird and reflected off some nearby pools. By taking a spotmeter reading of the bird and then overexposing by a full stop, I brightened the bird, exaggerated the contrast, and presented the dowitcher definitively against the dim scene. The exposure was f/2.8 for 1/60 sec. on Ektachrome 200 ED.

Here, two common terns at a nesting colony at New York's Jones Beach wrestle over a fish. I had to get as close as I could, about 20 feet, to record them in action. I made this shot with my Nikon F2, Nikkor 300mm telephoto lens, and Kodachrome 64, exposing for 1/500 sec. at f/5.6.

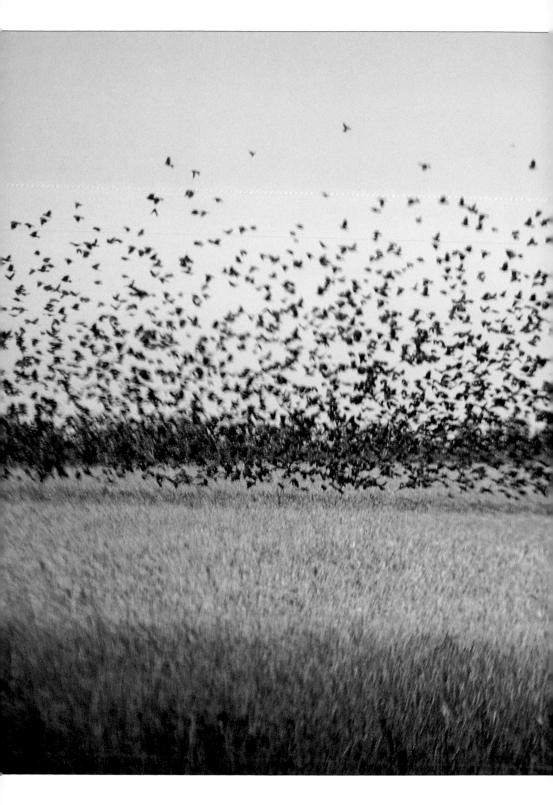

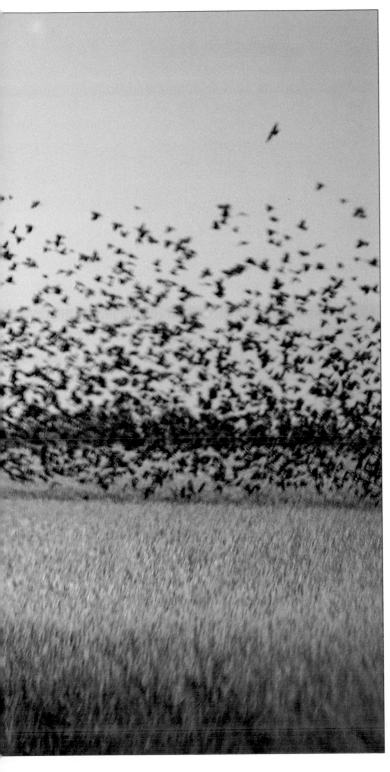

I decided to try photographing swarms of birds lifting off and flying en masse in a North Dakota field of red-wing blackbirds. To prepare for the shot, I composed carefully in such a way that the field filled the lower half of the frame and the sky filled the remainder. My hope was to capture the birds mostly against the sky; I had no expectation of recording any details. So I took a meter reading of the greens in the field and exposed slightly below the indicated reading, 1/2 stop, to saturate the colors. Next, I adjusted the shutter speed to 1/125 sec., the slowest setting I was willing to use in order to freeze the motion. This required an aperture of f/4, which wasn't ideal but was the best I could do. After that, I simply needed to wait for the decisive moment, which came shortly afterward. Here, I used my Nikon F2 and Nikkor 300mm lens, exposing for 1/125 sec. on Kodachrome 64.

A fairly wide-open aperture setting was required for this photograph of a flicker, which I made in Arizona. I wanted to blur the desert vegetation in the background for two reasons: to enable the bird to stand out clearly and to use a reasonably fast shutter speed. Because I was shooting at a distance of 12 feet, I recorded a good-sized image with my Nikkor 300mm telephoto lens. Precise focusing kept the bird sharp even though other parts of the image are slightly out of focus. With my Nikon F2, I exposed at f/4 for 1/125 sec. on Kodachrome 64.

When birds nest on the ground, you stand a good chance of finding and photographing one with the bird in attendance. I found this avocet in a North Dakota meadow by watching the movements of the mother bird. She kept returning to a certain spot, but I couldn't tell why until I got close enough. Luckily, I spotted the nest while the mother bird was away. I might have run into trouble otherwise: nesting birds aren't friendly to intruders. Next, I moved back to a point about 15 feet away, set up my shot, and waited for the mother bird to come back. As soon as she returned, she counted her eggs, and I pressed the shutter-release button. Working with my Nikon F2 and Nikkor 300mm telephoto lens, I exposed Kodachrome 64 at f/5.6 for 1/250 sec.

happens, you and your equipment may be in for an unpleasant—and disastrous—soaking.

FIELDS, MEADOWS, AND DESERTS

You can rely on birds to gravitate toward their primary food source. Fields and meadows, as well as deserts, are rich in the seeds and insects that are the staples of some birds' diets year round and during migratory seasons. You'll find the greatest range and numbers of potential subjects in warm weather when huge flocks of small to medium-size birds settle in and around grasses, sunflowers, and shrubs. If you can identify favorite locations and perches, you are likely to find various species, including blackbirds, meadowlarks, grouse, partridges, and bluebirds. In open areas, look for large birds, such as hawks and falcons.

The terrain of these environments offers good lighting conditions most of the time. Simplify exposure determination by setting your camera in the shutter-priority mode and at the fastest shutter speed to stop movement. Then, using center-weighted autoexposure, let your camera select the aperture setting. Don't use a polarizer; this would reduce expo-

sure by two f-stops. Do, however, use fast film. This is especially important because you'll probably use a fast shutter speed.

Remember, these birds tend to keep moving about all the time. If they land, they generally do so only for a few moments. (The main exceptions are birds of prey, which often perch atop poles or tall, bare treetops for long stretches of time.) So, once you find a promising spot, stay put and work quickly. Take a shot as best you can, and then refine it and take another as time permits. For example, look for birds engrossed in feeding. They are less likely to suddenly fly away if they are in the middle of a meal. You'll probably need to handhold your camera in order to stay flexible and mobile. An exception is when the bird is likely to be around for a while, such as at a nest.

Flight movements tend to be quick and erratic, making the motions of these sprightly birds particularly hard to capture on film. Increase your odds by aiming at a favorite perch or feeding spot. Then watch for telltale signs that your bird is about to fly away, or for the takeoff of entire flocks of birds above a field or meadow.

WOODLANDS AND FORESTS

These areas are the hardest environments in which to find and photograph birds. For the most part, these birds tend to be small and to feed and hide in treetops or among foliage. (The only exceptions are birds in rain forests.) Backgrounds are usually jumbles of confusion, so isolating birds is problematic. In addition, the dim or splotchy illumination in these environments makes determining exposure difficult.

Your best bet for photographing birds in woodlands and forests, such as kingfishers, is to find a location near a stream or pond. Here, birds are likely to swoop down toward the water for a quick drink. Then look for the branch along the water's edge on which they may perch while waiting for a safe moment to emerge. Remember that birds are creatures of

I photographed this beautiful tropical bird in a wooded area on Curaçao. I was so startled by its colors and markings that I can hardly retrace my decisions. I was working almost completely by instinct. I do remember, however, wanting to record a sharp image. Because I was unfamiliar with this bird, I chose a fast shutter speed of 1/125 sec. This, in turn, required an aperture setting of f/2.8 and precise focusing. Fortunately, the bird held its pose long enough so that I was able to get the shot I wanted.

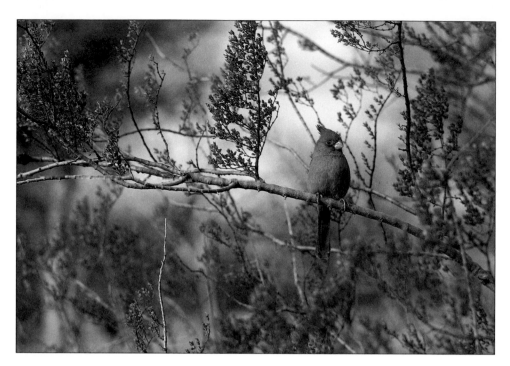

I noticed this pyrrholuxia in a thinly vegetated wild meadow in northern Michigan. This bird is the size of a cardinal, but has much better camouflage. My difficulties included getting a decent-sized image, separating the bird from its surroundings, and stopping motion caused by wind and by the bird itself. I had to work quickly before the bird flew away, so I used my Nikon F2 and Nikkor 300mm telephoto lens to make this establishing shot. I incorporated the habitat but found an opening in the shrubbery for a perspective that set the bird against the sky. Shooting Kodachrome 64 with my shutter speed set at 1/500 sec., I limited depth of field via an aperture of f/4.

habit, so they'll probably come back to the same perch again and again. You'll need a great deal of patience in order to be able to wait until the bird returns.

Since most woodlands and forest species are quite small—think of the warblers, woodpeckers, nuthatches, cardinals, and wrens—you must get within 10 or 15 feet of your subject, even with a 400mm telephoto lens, to make it remotely visible. Use every ounce of creativity you can muster to portray the immediate environment as a flattering frame for these small birds. Blur the background, but keep part of the surroundings reasonably sharp both to convey the sense of the setting and to let it help fill the frame. You probably won't be able to use a fast shutter speed in the low light of woodlands and forests. So you should mount your camera on a tripod to keep it steady during a relatively slow exposure.

To cope with the complexities of exposure determination in these environments, think in terms of low- or high-contrast conditions. In low-contrast lighting the entire scene is uniformly illuminated, even if it is generally dim. As a result, you should turn to your camera's autoexposure capabilities, setting the camera in aperture-priority mode. Simply open your aperture to its maximum width to let the most light enter the lens. This simultaneously limits depth of field—thereby blurring out the background—and permits you to use the fastest possible shutter speed.

You'll find high-contrast light on a day when bright sunshine penetrates the woods, but deep shadows are also visible. In this situation, manually exposure the scene. Take a meter reading of the bird with a spot meter, and then shoot at the meter reading with the aperture at its widest setting. Once again, this will render the background out of focus and enable you to use the fastest possible shutter speed.

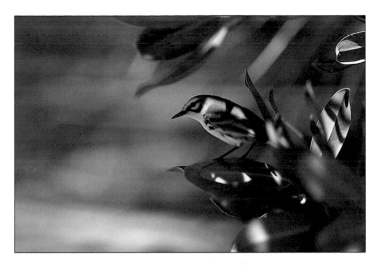

Many woodland species, such as this prairie warbler, are small and fidgety. While I was working in Florida, my primary challenge was to achieve a decent-sized image. I needed to use my Zuiko 350mm telephoto lens fitted with a 2X tele-extender to fill even this much of the frame. Another challenge was achieving adequate exposure. The woods had some bright spots, but they were basically dim. This meant selecting a wide-open aperture setting and a slow shutter speed. Despite these obstacles, I got my tiny trophy. Shooting with my Olympus OM-4T, I exposed Fuji-chrome 100 RD film for 1/60 sec. at f/2.8.

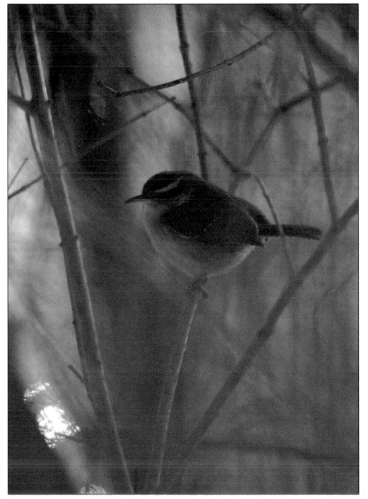

Chickadees are fairly ubiquitous, and you can find them in wooded patches of parks, gardens, and backyards. I shot this scene in a friend's yard in New York while the chickadee braced itself against a bitter winter chill. The small bird stayed in place long enough so that I was able to put a 1.4X tele-extender on my Zuiko 350mm telephoto lens. My primary concern was to shoot successfully from a distance of 10 feet, so I positioned myself carefully. The branches of the shrub framed the bird in a reasonably attractive and unobtrusive way. With my Olympus OM-4T, I exposed for 1/250 sec. at f/2.8 on Fujichrome 100 RD film.

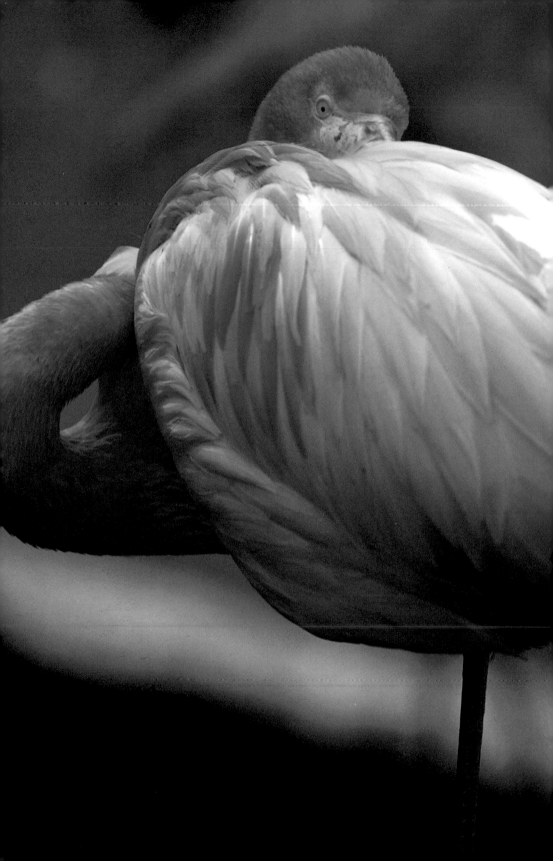

CHAPTER 6

Developing Fresh Perspectives

Getting out of a rut is critical to bird photography. One way to vary your perspective is to create tight, partial views of larger birds, like that of this flamingo, which I made at New York's Bronx Zoo. I was looking for a nearly pure abstract form here, so I simply played with my Nikkor 300mm telephoto lens until what I saw made visual sense. With my Nikon F2, I exposed for 1/250 sec. at f/4 on Kodachrome 64.

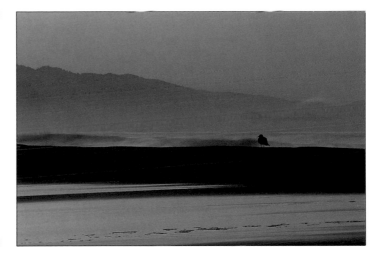

I created this abstract image by utilizing distant features of the landscape, treating the bird as just one of those elements. As I shot this scene at Point Reyes, California, the sunset colors and the shapes of the coastline predominated, but the small form of a gull serves as a reminder of what is literally on view here. Working with my Olympus OM-4T and my Zuiko 300mm telephoto lens, I exposed Fujichrome Velvia at f/5.6 for 1/30 sec.

When I started photographing birds, I couldn't afford very long lenses. If I wanted to take pictures of birds, I had to make do with the relatively short lenses I owned. My longest lens had a focal length of only 200mm. So I discovered what I could capture using the lenses I had. With a combination of determination and imagination, I learned that I could shoot many good images.

I came across this watery setting in Florida's Ding Darling Wildlife Refuge, a place that welcomes many birds. To evoke the spirit of the scene, I positioned this solitary egret just inside the sun's fiery reflection. I then intensified its brightness by overexposing slightly, 1/3 stop above the suggested meter reading. The contrast between the sunlight and the silhouetted, solitary form underscores the grand scale of the environment. Shooting Fujichrome 100 RD film with my Olympus OM-4T and Zuiko 350mm telephoto lens, I exposed at f/2.8 for 1/30 sec.

I often think about those early years. They remind me that a lack of resourcefulness and whimsy is a bigger obstacle to taking fine bird images than a lack of some piece of equipment. The right gear can help you produce a particular image, but it can't tell you what kind of image to take. For that, you need to hone your creative capacity and develop fresh perspectives on photographing birds.

As you explore each habitat, by all means use the opportunity to practice the complex photographic skills you need to develop greater confidence as a bird photographer. But don't stop there. Expand your individual vision, and progress in your ability to conjure up various kinds of images.

This final chapter covers different ways to look at and depict birds. The idea isn't to be different for the sake of difference, but to develop flexibility, so that you find valid ways of portraying birds, regardless of the circumstances. You also need to find ways to break habits of seeing, so that you don't fall into a rut, visually speaking. Think in terms of switching from what you're accustomed to, to something else, something new—a different lens, angle, perspective, or approach. When you free yourself up, the possibilities will expand to fill the new space you've opened. In short, once you've mastered your equipment so that it can do your bidding, you should take some time to rethink the bidding itself.

BIRDS IN THEIR SETTINGS

Whether by necessity or design, one perspective you are likely to frequently turn to is showing birds in their settings. The necessity derives from the simple fact that it is hard to get close enough to most birds, so that they alone fill the frame. The design derives from the variety of ways the surroundings can enhance a bird image, providing both information and an aesthetic framework. How can you make the most of such panoramic perspectives? Here are some suggestions to get your juices flowing:

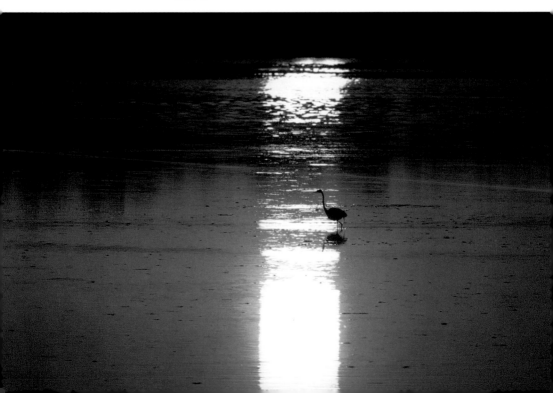

■ Document flocks of birds in their environment. You can effectively show large flocks of birds against a vast natural backdrop or in relation to a more intimate portion of the setting. Treat such images as if they were landscape shots, with the birds as part of the environment. Such photographs offer useful information and serve as reminders of the magnificent settings you saw. And by keeping an eye out for movement, you can portray the birds in flight or engaged in some other common activity.

■ Evoke the spirit of the place. Instead of straightforward documentation, try to capture the emotional essence of the scene. Position the bird or birds within the setting in a way that emphasizes the character of the place, the mood of the atmosphere or the quality of the light. For example, evoke the texture of grasses or the shimmering, reflective surface of the water, with birds as visible players in the show. In other words, concentrate on bringing out the special elements of the setting, but place your bird subjects in a distinct relationship to the context.

■ Capture the excitement of a single bird within the scene. Nothing quite matches the sight of an individual bird going about its business spontaneously, oblivious of your presence. Frame the scene, so that the bird is clearly featured, but make the setting the stage for the star attraction. This can be an egret stalking fish, a cardinal nibbling berries, or a duck tending its young. Even a simple portrait of a motionless bird is much more interesting when the surroundings add both color and texture to the image.

Remember that the exact perspective you achieve from a given distance depends on the lens you choose. So frame your shot with a few different lenses—even a wide-angle lens—to see how they combine birds with their settings. Another option is turn to your zoom lens for the most flexible composing. Of course, your own creativity and imagination will ultimately become your truest guide.

The setting is the main attraction in this shot of a Kansas sunflower field, but the arrival of a female red-wing blackbird added just the homey touch the picture needed. I framed the bird to the left of center looking right. Then I focused on the bird using a small aperture setting to achieve extensive depth of field. Here, I used my Olympus OM-4T and Zuiko 35-70mm zoom lens, exposing at f/11 for 1/60 sec. on Fujichrome Velvia.

GROUPING BIRDS

Another shot to try is the equivalent of a group portrait. Such middle-distance vignettes are viable options whenever you are too far away to shoot true closeups, but are close enough to fill the frame with anything from an entire flock to a small coterie of birds.

Framing a group of birds requires you to change your thinking somewhat. You need to take into account all the factors you have to juggle at once. One way to make this mental shift is to ponder the difference between the way you might shoot an individual portrait and a family portrait. The family grouping is more than the sum of its parts. It must show a sense of balance and harmony among the individuals. In the same way, you'll have to define the group of birds and organize them into an effective whole. Consider the following factors as you make your choices.

Composition. Pay careful attention to composition, much more than you would when photographing a single bird. Consider the shapes of the individual birds as if they were abstract elements, and then find a perspective that offers insight about how their forms interact. For example, repeating forms or patterns draw they viewer's eye along imaginary lines. Frame a row of sandpipers as they scurry together along a shore. You can also portray the contours of a group of birds in profile, facing the same way or in opposite directions for an interesting series of repeated forms. If you're grouping different birds, contrast their sizes, shapes, and colors within an orderly arrangement. And take advantage of any contrast in light to set the group apart from its surroundings and to differentiate the various members from one another.

Choice of Lens. Which lens you choose depends on the effect you want to create. At first, you should experiment with a few lenses or with your zoom lens to see which frames the cluster of birds best. Also, consider

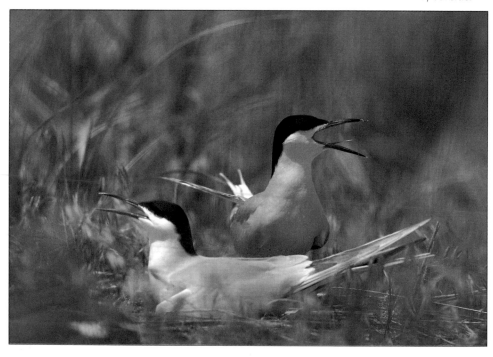

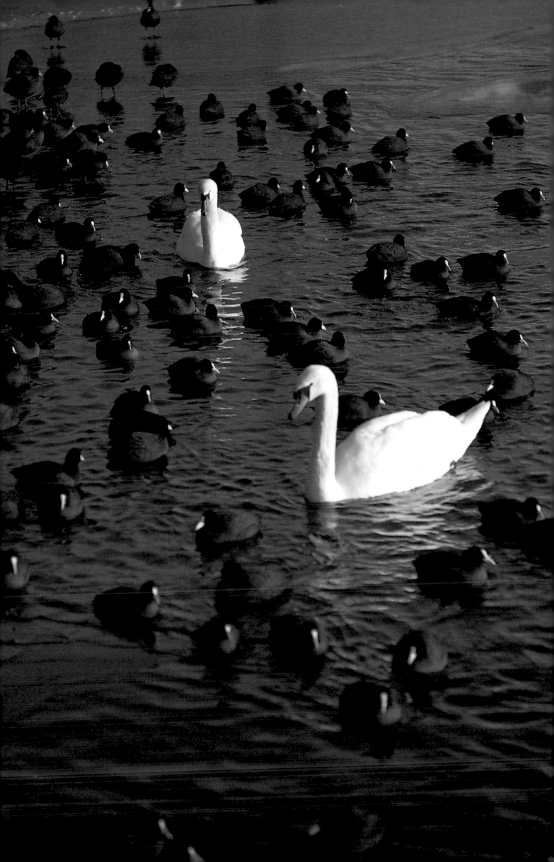

I needed to simplify the backdrop behind this small warbler in Bonaire in order to emphasize its individuality within the frame. To enlarge the bird enough so that it would be clearly visible, I fitted my Zuiko 350mm telephoto lens with a 1.4X tele-extender. This high magnification, combined with a wide-open aperture setting, reduced the depth of field and threw the busy background completely out of focus. As a result, the spotlight was on the warbler. Then to maintain proper exposure and still be able to use a fast shutter speed, I pushed the film a stop. With my Olympus OM-4T, I exposed Fujichrome Velvia at f/2.8 for 1/125 sec.

how each lens shows the relationship between the birds and their habitats. After selecting a wide-angle or standard lens, use a low or high perspective as a way to combine a group of birds with its environment from a relatively close distance. Conversely, to isolate birds from their settings, compress the space between the birds in a group. And to magnify a group of faraway birds, choose a telephoto lens.

Be Patient. Because birds move all the time, photographers have a tendency to be too quick to start working. In most cases, you are better off waiting until shooting conditions are just right. Don't bother shooting if you aren't close enough to your subject. Get at least as close as you need to, to show the group of birds together. Then be patient, so you get an arrangement that works aesthetically. As birds move, they'll fall into various configurations. Be ready to shoot as soon as an effective, compelling structure seems clear. Also, you need to understand the likely behavior and movement of the birds to know what to expect. And use a fast shutter speed at all times to stop their motion.

THE INDIVIDUAL BIRD

If you have the opportunity to get close enough to portray a single bird so that it fills a generous part of the frame, you'll surely want to take advantage of it. This is the perspective most people have in mind when they begin to photograph birds. But bird portraits have their pitfalls and difficulties. The biggest challenge you'll encounter is achieving adequate bird size. A single bird doesn't have to occupy the entire frame, but it should be identifiable and distinct. The biggest danger, however, is boredom. This is because portraits of individual birds have a disturbingly similar look about them, something akin to bird mug shots. Here are some suggestions to help you avoid falling into that trap:

■ **Use vertical and horizontal formats.** Break any tendency you have to use a horizontal format all the time. This is the one most photographers favor, but it isn't always for the birds. You should train yourself to shoot in both formats.

■ **Simplify the background.** An easy way to increase the power of your bird portraits is to keep the background simple. This technique accomplishes two important tasks. First, this strategy helps to set off the bird. In addition, it dramatizes the subject's value in the frame. You can use contrasty light to create a primarily black backdrop. Another option is to use an element with a single contrasting color, such as green vegetation, behind the bird. Still another possibility is to limit depth of field in order to blur out the background. You'll find that even a slightly out-of-focus setting helps define your bird subject.

■ **Utilize reflections.** Since birds are often around water, work with reflections whenever you can to boost the impact of the bird. Such reflections don't have to be crystal clear, but they do have to stand apart in terms of light contrast and color.

■ **Show activities.** Even if you want the bird to be still during the instant you release the shutter, aim for a shot at a decisive moment that shows an interesting behavior. The movement doesn't have to be a once-in-a-lifetime rarity. In fact, ordinary activities are best. Just anticipate what the bird will do, and be ready when the moment arrives.

■ **Experiment with sharpness.** In most cases, you'll want a sharp image of your bird. At the very least, keep the bird's eye sharp and, if possible, show a glint in eye. If this gleam is hard to see, get the beak in sharp focus. However, don't limit yourself to strictly sharp images. For example, experiment with fast films for a grainy, soft-focus look. Or try a spot-focus filter, which keeps only the center of your image sharp. These effects may not be appropriate at all times, but they may be just what you need to obliterate a chaotic setting.

I always prefer photographing a bird engaged in a typical activity to shooting a plain portrait. Bird portraits often require photographers to give up their own activities and to be quite patient. I needed to do both to get this shot of a little blue heron a moment after it caught its lunch in Florida's Corkscrew Swamp. I watched the bird for some time as it stalked its prey. I was all ready to shoot: I'd mounted my Olympus OM-4T and Zuiko 350mm telephoto lens on a tripod; selected my film, Ektachrome 64 Professional EPX film; set the shutter speed at 1/250 sec.; and determined the corresponding aperture, f/4. Finally, both the bird and I got what we were looking for.

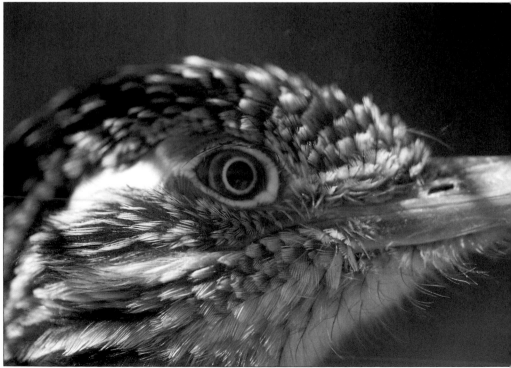

PARTS OF THE WHOLE

While few photographers intend to shoot nothing but details of birds, these are fun perspectives to explore. They are particularly fascinating because they show birds in a way that people can rarely see with the naked eye—or even with binoculars. And, as with other types of photography, one of the joys of using a camera is to capture aspects of the natural world that wouldn't ordinarily be accessible. Also, chances are you'll be able to get such details only with fairly large birds and only if they are quite still.

Because this perspective exaggerates and enlarges parts of a bird, the particular detail must fill the frame completely and must be graphically strong. That means you have to get very close to the bird and choose the right lens for that distance. If necessary, add extension tubes so you can get closer than minimum focusing distance of your lens.

Then build your image around texture, color, and abstract design. Choose a feature that stands out in some way: the texture of the bird's feathers; the color of its head, beak or markings; the line of its neck—anything that can stand on the strength of its graphic value.

UNCOMMON VIEWS

Bird photographers are likely to turn to several other perspectives. Though these are less common, they should become part of your shooting repertoire.

■ **Bird flying overhead.** This isn't an easy perspective, but it is one that many photographers try with little success. The major challenge is to expose well for both the bird and the sky; if you have to choose one, by no means underexpose bird. If the sky is bright, you may need to open up to get detail in the feathers of the bird. This may cause overexposure on the sky, but that is preferable, in most cases, to a bird silhouette. If the sky is too pale, try sandwiching with another photograph afterward (see below).

To capture the bird as it hovers or glides above, pan the bird smoothly at your fastest shutter-speed setting—but at least 1/125 sec. Take several shots in a row using your motorwinder or motordrive. Compose as best you can with bird at the center of the frame.

■ **Down from above.** A good way to show the markings of ducks and other birds is from above. You have to be fairly close to bird for this per-

Because I was able to get within 9 feet of this mallard in a Michigan park, I decided to feature its purple speculum, a defining field mark. Although the image is fairly abstract, the well-defined texture of the feathers makes it clear that it is part of a bird. With my Olympus OM-4T and my Zuiko 50-250mm zoom lens, I exposed Ektachrome 100 Lumière LPP film at f/11 for 1/30 sec.

Few people ever get to see a roadrunner this close up. When I noticed this bird only 8 feet away from me in the Texas countryside, I knew that I had a chance to shoot a different kind of photograph. After I fitted my Nikkor 300mm telephoto lens with a 25mm extension tube, I blew up the bird's face, staring right into its eye and marveling at its intricately patterned feathers. This is the beauty of still photography: it enables viewers to see things they can't ordinarily see, and it preserves these subjects for slow study and contemplation. With my Nikon F2, I exposed at f/2.8 for 1/125 sec. on Kodachrome 64.

Although birds routinely fly overhead, most photographs of this perspective are far from enchanting. I shy away from this viewpoint because it often isn't worth the trouble. I did try, here, however, because the common tern flying over New York's Jones Beach had a sharply defined shape and the sky was a brilliant blue. Shooting with my Nikon F2 and Nikkor 300mm telephoto lens, I exposed for 1/500 sec. at f/5.6 on Kodachrome 64.

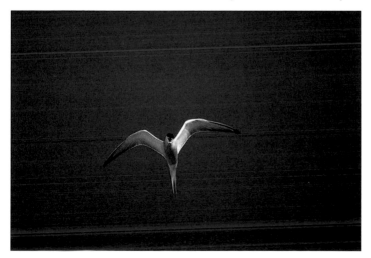

spective, so find a small footbridge, a nearby window or terrace, an over-pass, a path, or a blind—any structure that allows you to look down on the birds. If you are close enough, you may be able to use a standard or even a wide-angle lens, although a 35-70mm zoom lens will give you the most compositional options.

■ **Through vegetation.** Since birds often hide among grasses and reeds, it is the wise photographer who learns to take a perspective that shoots through vegetation, using the greenery to frame the bird attractively and suggest its habitat. Technically, this calls for getting as close as possible to the grasses and blurring out the foreground vegetation with a telephoto lens. Keep your lens wide open to minimize depth of field. A wide-open aperture also lets you see exactly what will be in focus and what won't, and it automatically gets you to use your fastest possible shutter speed.

IMAGINATIVE VARIATIONS

Some bird images defy conventional expectations completely, yet these can be among the most original ways to portray birds. You wouldn't

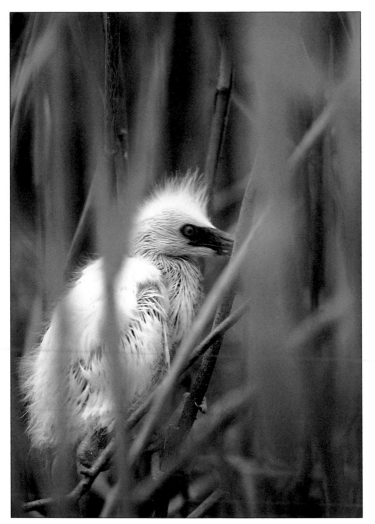

I noticed this egret chick struggling to stand among the grasses at New York's Jones Beach. I wanted to record this moment of discovery by recreating the sensation of looking through the vegetation. By crouching down and using my Nikkor 200mm telephoto lens, I was able to blur the grasses right in front of me, as well as to keep the young bird in sharp focus. With my Nikon F2, I exposed at f/5.6 for 1/125 sec. on Kodachrome 64.

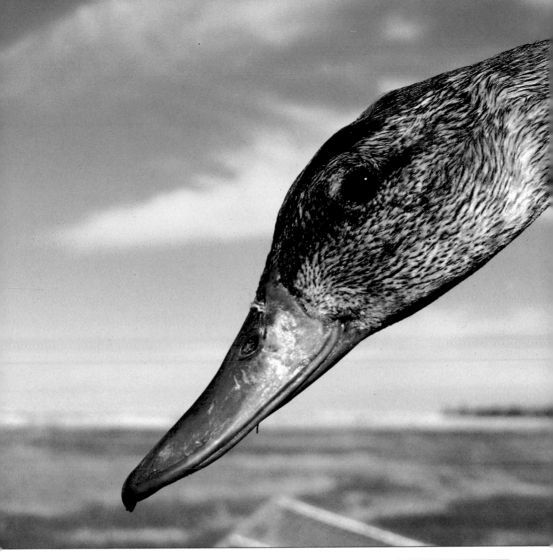

necessarily make them your prime objective, but under the right conditions they can produce most unusual results, even rescuing what would otherwise be impossible circumstances.

A good example of such imaginative variations is a silhouette. Silhouettes can truly make the most of a bad situation, namely when the background is much brighter than bird. Rather than walk away from such a predicament, try to work with it skillfully. Meter the bright background and shoot at the reading or underexpose to deepen the colors of the scene. Your bird subjects will record as silhouettes, but their simple black forms, if well composed, will still be telling and impressive images.

You must be a bit daring to go for deliberate blurs, but if you're willing to take your chances and work at the results, you may be rewarded with some unusually evocative bird images. Think about the kind of movements that lend themselves to deliberate blurs. Takeoffs and landings work better than short, quick motions, like spearing a fish. Then shoot at a slow shutter speed, 1/60 sec. to 1/15 sec., depending on how fast the bird is moving and the kind of blur you want. And remember to press the shutter-release button an instant before the action occurs.

I was working with some naturalists in Michigan who were banding birds. After the birds were banded, they were thrown into the air to set them free. When I noticed this mallard was struggling to escape, I realized the potential for an amusing wide-angle shot. From a shooting distance of only 1½ feet, I framed the bird's head against the countryside in the distance. With my Nikon F2 and Nikkor 24mm lens, I exposed at f/5.6 for 1/125 sec. on Kodachrome 64.

I created a different type of sandwich shot by combining an image of roseate spoonbills in flight with one of the sun setting behind the clouds. Working in Florida, I used my Olympus OM-4T and Zuiko 350mm telephoto lens. The exposure on Fujichrome 100 RD film was f/2.8 for 1/125 sec.

When I came upon this egret in Florida, I decided to shoot a silhouette because I liked the delicacy of the bird's form. The original image worked, but I didn't consider it sufficiently graphic and dramatic. So I envisioned the image again. I tried using a few sunset shots from my collection before I hit upon this compelling combination. With my Olympus OM-4T and Zuiko 350mm telephoto lens, I exposed Fujichrome 100 RD film at f/5.6 for 1/125 sec.

Ideally, your image will show movement but retain the identity of the bird. But there is no way to know exactly what you'll get, so keep shooting at different shutter speeds to get a variety of images. Such shots work best with your camera mounted on a tripod, but you can try them with a handheld camera as well. Keep in mind, however, that this may cause the entire image to blur.

You can create all sorts of ingenious images by combining two transparencies that complement one another in color, shape, and graphic design. Such "sandwiches" work particularly well if one image shows the sun, sky, clouds, or reflections on water while the other shows one or more birds. This is a good way to enhance your silhouettes and rescue any nature images that were overexposed. Experiment by stacking two or three images on a lightbox. If you like the results, have a custom house make a dupe that merges the images.

With these fresh perspectives in mind, you are ready for a lifetime of bird photography. Good luck!

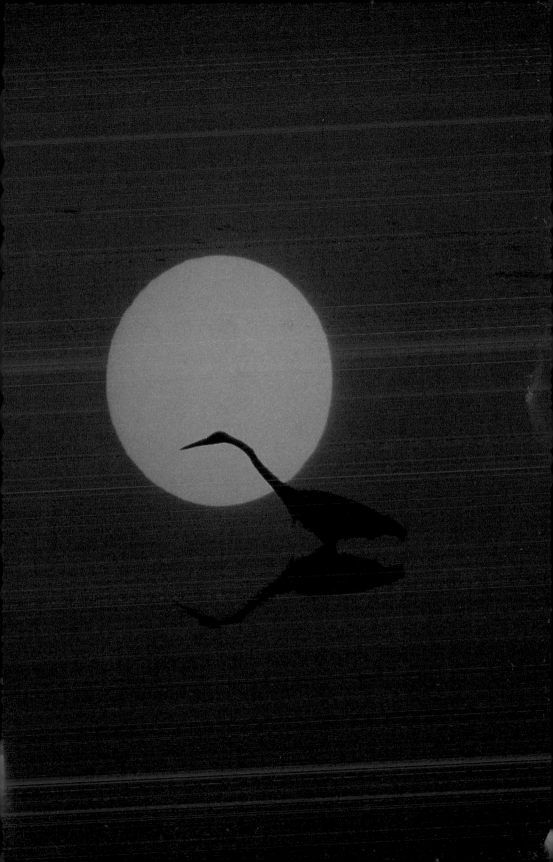

Index